BRIDGET RILEY

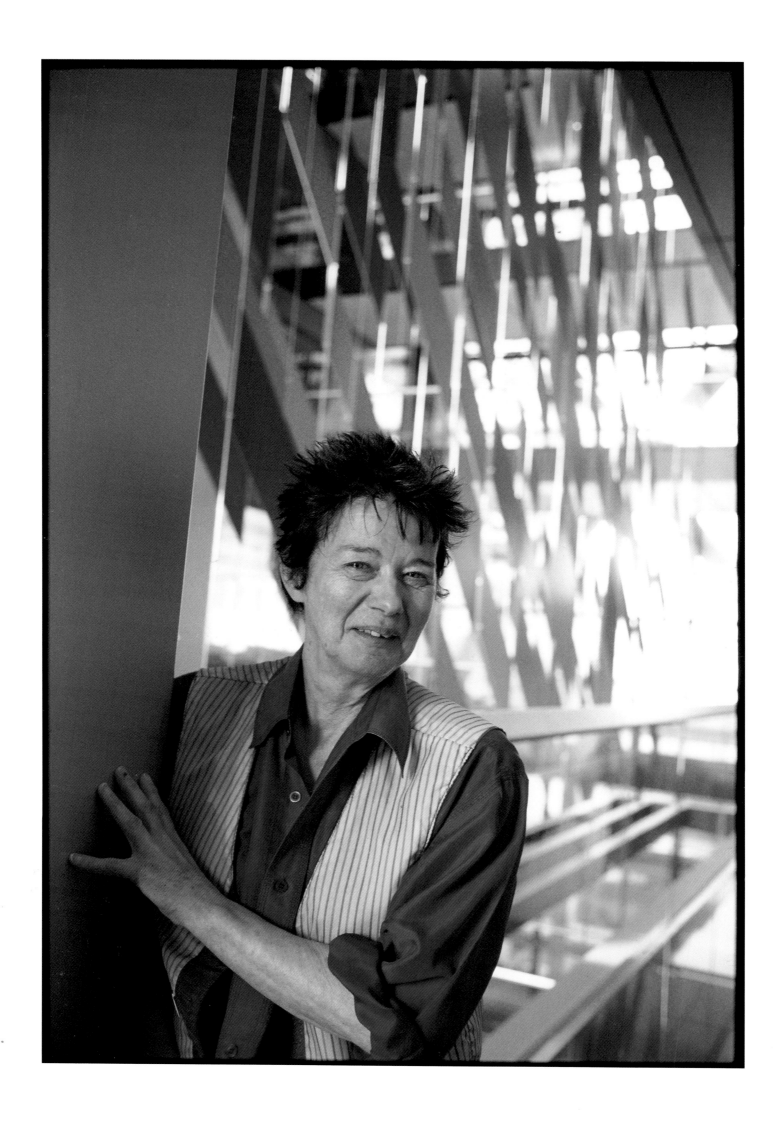

BRIDGET RILEY

Paintings and drawings 1961–2004

Museum of Contemporary Art
Sydney, Australia

City Gallery Wellington
Wellington, New Zealand

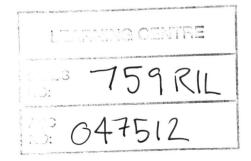
Ridinghouse · London

First published in 2004 by Ridinghouse, London, on the occasion of the exhibition

Bridget Riley Paintings and drawings 1961–2004

Museum of Contemporary Art, Sydney, Australia
14 December 2004 – 6 March 2005

City Gallery Wellington, New Zealand
23 March – 26 June 2005

ISBN 0-9541710-6-3 (paperback)
ISBN 0-9541710-7-1 (hardback)

Designed by Tim Harvey
Printed in Great Britain by St Ives Westerham Press

Measurements of works of art are given in centimetres, height before width,
followed by inches.

Exhibition organized by

BRITISH COUNCIL

Contents

Sponsors

Museum of Contemporary Art, Sydney

Major Sponsor

Supported by

The Museum of Contemporary Art gratefully acknowledges the ongoing funding and support of the New South Wales Government and 'Key Organisation' grant funding from the Commonwealth Government through the Australia Council, its arts funding and advisory body. The MCA was established by the University of Sydney through the J.W. Power Bequest, with the assistance of the New South Wales Government.

City Gallery Wellington, Wellington

Major Sponsor

ƎIJ ERNST & YOUNG

Supported by

City Gallery Wellington Foundation

City Gallery Wellington is managed by the Wellington Museums Trust with major funding support from the Wellington City Council.

Lenders

Acknowledgements

Public Collections

Art Gallery of New South Wales, Sydney
Arts Council Collection,
 Hayward Gallery, London
British Council
Museum of Contemporary Art, Sydney
National Gallery of Australia, Canberra
National Gallery of Victoria, Melbourne
Queensland Art Gallery, Brisbane
Sheffield Galleries and Museums Trust
Tate, London

Private Collections

Kerry Stokes Collection
N.M. Rothschild & Sons Ltd.
Private lenders who wish to remain
 anonymous

The organizers of the exhibition would
like to express their thanks to the
following individuals and institutions,
without whose help and support this
exhibition would not have been possible.

Julian Barrow
Douglas Baxter
Ann Chumbley
Catherine Clement
Jill Constantine
Lynne Cooke
Sue Corfield
Thomas Dane
Adam Gahlin
Stuart Garland
Arne Glimcher
Victor Gray
Wilfried von Gunten
Jenny Harper
Tim Harvey
Lisa Hayes
Thomas Johnson

John Johnson
Sofia Jonsson
Robert Kudielka
Paul Le Grand
Douglas McFarlane
Paul Moorhouse
John Parfitt
Roy Pateman
Julie Prance
Denise Reid
Takeshi Sakurai
Susanne Schär
Dominik Stauch
Jodi Smith
Sean Williams
Peter Young

Exhibition organisation

London

Karsten Schubert

Andrea Rose
Director Visual Arts, British Council

Brett Rogers
Head of Exhibitions, British Council

Caroline Douglas
Exhibition Curator, British Council

Dana Andrew
Exhibition Assistant, British Council

Diana Eccles
Collections Manager, British Council

Gareth Hughes
Manager, British Council Workshop

Philip Young
Conservator

Sydney

Elizabeth Ann Macgregor
Director, Museum of Contemporary Art

Vivienne Webb
Curator, Museum of Contemporary Art

Judith Blackall
Head of Artistic Programs, Museum of Contemporary Art

Karen Hall
Assistant Registrar, Museum of Contemporary Art

Christopher Snelling
Head of Marketing & Communications, Museum of Contemporary Art

Amanda Sharrad
Exhibitions Coordinator, Museum of Contemporary Art

Simon Gammell
Director, British Council Australia

Grainne Brunsdon
Assistant Director, British Council Australia

Wellington

Paula Savage
Director, City Gallery Wellington

Greg O'Brien
Curator, City Gallery Wellington

David Chin
Manager Business Marketing & Development, City Gallery Wellington

Tracey Monastra
Programme Manager, City Gallery Wellington

Neil Semple
Exhibition Manager, City Gallery Wellington

Anita Hogan
Registrar, City Gallery Wellington

Paula Middleton
Director, British Council New Zealand

Jodie Molloy
Arts Manager, British Council New Zealand

Foreword

Elizabeth Ann Macgregor, Director, Museum of Contemporary Art, Sydney
Paula Savage, Director, City Gallery Wellington

Bridget Riley's distinguished and singular career encompasses more than four decades of remarkable innovation. As an internationally renowned artist and one of Britain's most respected abstract painters, her works create compelling visual experiences that challenge our senses and perceptions. In the 1960s Bridget Riley's ground-breaking paintings tended to be associated with youthful vitality and the cosmopolitan spirit of the times. Today the energy of those paintings is undiminished, and the early canvases now configure as the opening chapter in a rigorous and unwavering career which is still very much in progress.

The Museum of Contemporary Art, Sydney, and City Gallery Wellington are delighted to collaborate with the British Council in bringing a comprehensive retrospective of Bridget Riley's work to Australia and New Zealand. There have been a number of recent exhibitions in Europe and North America, and it is timely to see a major survey of the artist's work tour the region.

The exhibition includes 35 canvases dating from 1961 to the present: a comprehensive survey of Riley's work illustrating the stylistic shifts in her creative output. These include a selection of her acclaimed early black and white works which explore the optical creation of spatial relationships. They chart the development of a distinctive formal language that has rejected subjective, personalized brushwork in favour of a more systematic investigative approach and minimal aesthetic. From 1967 these investigations have incorporated vibrant colour effects, from slender stripes using a restricted palette through to the magnificent large-scale curve paintings from the last decade. The exhibition includes a large group of studies and works on paper which reveals Riley's meticulous artistic process, and at the MCA there is also a new wall drawing created for one of the museum's vaulted galleries.

We are particularly indebted to the artist, whose generosity and commitment have ensured the successful realisation of this touring exhibition. Her agent Karsten Schubert has made a significant contribution to the planning of this project and we are extremely grateful for his support and enthusiasm.

This exhibition, tour and publication have been drawn together by the British Council and we would like to thank Andrea Rose, Caroline Douglas and Dana Andrew for such a collaborative and rewarding experience. Works have been sourced from major public and private collections including the Tate and the Arts Council collections. We would like to express our gratitude to all of the lenders for their commitment to the exhibition. It is especially pleasing that this comprehensive survey provides the opportunity to showcase major works from local collections in the context of a detailed overview of the artist's practice.

The substantial catalogue has been produced by the British Council, with additional generous support from Karsten Schubert. It features texts by Lynne Cooke, Paul Moorhouse and an interview with the artist by New Zealand scholar Jenny Harper.

The MCA would like to thank the sponsors of the exhibition, in particular our Major Sponsor Baker & McKenzie for their support in assisting the museum in bringing Bridget Riley's works to Sydney's shores. Thanks also to Supporting Sponsor JCDecaux and Television Media Sponsor Seven Network for their assistance in promoting the exhibition, and to MCA Leading Sponsor Telstra for providing free admission to the exhibition.

City Gallery Wellington wishes to thank Principal Sponsor Ernst & Young for their generous ongoing commitment and financial support as Principal Corporate Benefactor of City Gallery Wellington Foundation, support which made this exhibition possible in New Zealand. We also wish to acknowledge the core funding support of Wellington City Council through the Wellington Museums Trust.

Painting with Two Verticals 2004
Oil on linen
192.4 × 261.6 cm / 75¾ × 103 in
(not exhibited)

'The ultimate secret of things'
Perception and sensation in Bridget Riley's art
Paul Moorhouse

'In [dealing with] a product of fine art we must become conscious that it is art rather than nature...'[1] Written in the eighteenth century, Emmanuel Kant's observation anticipates one of the central premises of Modernism: the liberation of visual art from the literal depiction of the observed world, and instead an emphasis on those characteristics which define a work of art as a thing that exists on its own terms. During the 1960s, when Bridget Riley first gained international recognition, this Modernist imperative had reached its greatest intensity. In some ways, the paintings she began to make from 1961 onwards can be seen as reflecting the ethos of those times. Insistently abstract, and executed in black and white only, all traces of the external world seemed expunged. In the place of recognizable imagery, simple shapes – squares, circles, ovals and triangles – were structured in increasingly complex and subtle ways. However, as was apparent from the start, these paintings could not be explained – or experienced – simply as formal arrangements.

Riley's early paintings radically reversed the traditional

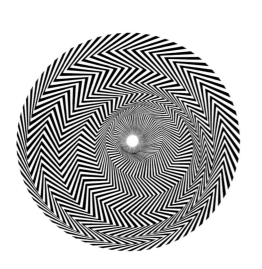

Blaze 1
1962
Private
Collection
(cat. 5)

relationship between the work of art and the viewer. The conventional assumption is that a painting is an essentially passive thing: an inert, unchanging image over which the viewer's gaze roams freely. Her work shattered this expectation. Looking at Blaze 1 1962, for example, involves being drawn, instantly, into a dynamic relationship with a work of art. In that relationship, the painting does not exist simply as an arrangement of shapes which undergo disinterested inspection. Instead, the process of looking 'activates' the painting. Its formal structure is catalyzed and destabilized by the viewer's gaze. As the mind struggles to interpret the sensory information with which it is presented, it veers from one visual hypothesis to another, vainly trying to fix the image. This state of flux generates vivid perceptual experiences of movement and light, which are the defining characteristics of Riley's early work.

Such experiences cannot be explained solely in terms of formal arrangements. The paintings utilize precise structures, but not as ends in themselves. They invite and accommodate the viewer's gaze, but then go beyond this. The viewer is drawn into a dialogue with the painting. The mind's formation of an image is fed by a build-up of visual sensation, the source of which is the work. The appearance of the painting is, as Riley has explained, 'as much inside one as it is "out there".' Intriguingly, such perceptual experiences generate an impression of independent life within the painting itself. In the performance enacted by Blaze 1, for example, the viewer is both complicit and spectator. The appearance of rotation is generated by the act of looking, but such movement is surprising – and not entirely controllable. It is this phenomenon – an insistent emphasis on the 'relationship' between the mind of the viewer and the external fact of the painting – which singled out and established Riley's art. But how is this phenomenon to be explained?

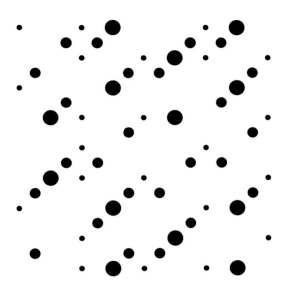

White Discs 2
1964
Private
Collection
(cat. 8)

In foregrounding the role of perception, Riley's art engages with our experience and understanding of the world at a fundamental level. A new-born infant's view of its surroundings is untainted by experience. Open to pure visual sensation, its eyes are sensitive to movement and they receive light and colour uncritically – as essences in themselves, without an intervening structure of recognition. The world – not yet an arena of 'things' – discloses itself as a tapestry of chromatic shapes in gradually emerging relationships. This is our universal, primary experience. Subsequently, with the accumulation of experience, the infant develops the ability to distinguish one sensation from another, to recognize the recurrence of certain sensations, and to make connections between familiar sensations. From the level of inchoate sensory experience, and by a process shrouded in mystery, the human mind gradually takes shape: imposing its structure, drawing the world into patterns of familiarity and comprehensibility, and constantly adding to its growing stock of concepts. The world and the mind become joined in an ongoing exchange – occupying a realm we call 'perception' – a plane of experience at once private and unique to each individual, yet a universal, essential aspect of human existence. Hidden from our understanding, perception nevertheless lies at the centre of our being. This is the area of experience which Riley's art investigates and celebrates.

Perception

Between 1961 and 1966 a major imperative appears to have been the will to make the perceptual process visible. White Discs 2 1964, for example, is radically different in character from Blaze 1 but, like the earlier painting, we are made forcibly aware that the experience of the painting is essentially subjective. What we see, in looking at the painting, is not simply its surface characteristics; rather, the visual experience of the work is intimately connected with our inner responses to it. Indeed, the overwhelming impression is that it is only in looking that the true nature of the painting is revealed and completed. As in Blaze 1, the perceptual leap in White Discs 2 is relatively fast. The initial (sensory) phase when the eye accepts the motif passively is defined by a fleeting impression of rows of black discs, of varying size. This view is very quickly overtaken by a secondary (perceptual) stage which is marked by the appearance of numerous ghostly white discs – after-images – which exist alongside their black progenitors. A third, open-ended phase is characterized by the viewer's interaction with the situation as it is now presented. In this stage, the eye moves freely around the pictorial space, alternating between the apprehension of real and virtual images. This process is self-sustaining in that the white after-images reappear, fade and are regenerated indefinitely. The capacity of Riley's art for regeneration, using elements from within itself, is a remarkable aspect of her work. It has a perceptual dimension, as in this instance; it also takes the form of formal themes which are recycled in different guises at various points in her career; and, as will be seen below, it takes the form of formal strategies used to develop and continue the visual argument within an individual work.

Of course, perception informs existence at every waking moment, and is not confined to such overt demonstrations of the relationship between the external world and our inner, private experiences. However, so accustomed are we in our everyday lives to this ongoing dialogue between 'the inner and the outer'[2], that the presence of this vital process goes overlooked. Indeed, arguably a substantial number of people are completely unaware of the role of perception, and go through life believing that the real external world is exactly as it appears to us. Riley's early paintings challenge that

assumption. There is nothing in her art that cannot be found in nature, and no difference in kind or subterfuge is involved. But, using simple real, primary elements – shapes – and the relationships between them, her paintings place before us the inescapable evidence that visual experience is a construct comprising elements external to us and our subjective interpretation of our sensory experiences. This, perhaps, is why some people find Riley's work disconcerting: it reveals a truth which, for some, upsets beliefs ingrained since childhood.

This is not to say that her work functions as a radical demonstration of certain philosophical theories of perception. Indeed, as Riley has pointed out, she has never studied optics and, though the structures of her paintings are carefully judged, her knowledge of mathematics is confined to 'equalizing, halving, quartering and simple progressions.'[3] Nor has she made a close study of philosophy. Rather, her work is deeply rooted in empirical truth, revealed through a capacity for intense looking and, from childhood, based on a love of nature. Her work is founded not on theory, but on a profound adherence to the 'pleasures of sight'[4] as a positive, illuminating and sustaining force in life.

The notion that Riley's art, in comprising simple, non-representational shapes, is therefore locked into itself and sealed against the world, is a mistaken assumption and one that particularly characterized critical responses in the 1960s. Such readings tended to focus on the 'optical effects'[5] which were held to characterize her work, the implication being that such effects were an end in themselves, and even connected with being visually 'aggressive'[6]. Riley's essay 'The Pleasures of Sight' (1984) was a useful corrective, making the relevance of nature apparent. In that piece, Riley recalled her 'childhood in Cornwall, which of course was an ideal place to make such discoveries. Changing seas and skies, a coastline ranging from the grand to intimate, bosky woods and secretive valleys; what I experienced there formed the basis of my life.'[7] She concluded:

> Naturally, as a child one is more open to such experiences. When one gets older these tend to take place less often – that is, they seldom appear any longer as pure revelations. But this does not mean that one has come to see things as they really are or any more truthfully. The damage is done by the daily round with its heavy load of pressures and preoccupations which come between, like a plate glass window, and through which one can certainly see but through which no vision can penetrate. It seems to me that as an artist one's work lies here.[8]

Riley's point is that, with age, the intense visual experiences that characterized childhood recede. She implies that the accumulation of experience, rather than sharpening our knowledge of the world, instead places a barrier between our surroundings and the ability to respond.

In manifesting these passions and convictions, her work demonstrates an intuitive grasp of certain philosophical ideas. Such ideas are therefore a useful tool for shedding light on the apparent paradox of an artist who, by her own admission, has a close, enduring affinity with nature, and yet, whose work, at first sight at least, seems resolutely abstract and unconnected with anything outside itself. Consider now Schopenhauer, Kant's intellectual heir and one of the greatest of those philosophers who have attempted to penetrate and explain the mysteries of perception. In his masterwork, *The World as Will and Representation* (1851), Schopenhauer argues that we acquire a knowledge of the world through our immediate perceptions, and that these form the basis of concepts which we develop and use to order, rationalize and retain our experiences. In the absence of an actual experience, we can recall or represent it to ourselves, by forming a concept – a mental symbol – of the

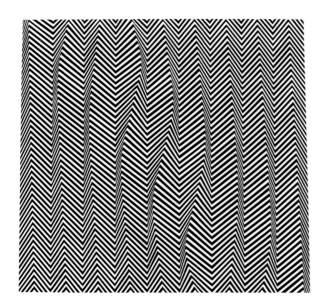

Descending
1965
Private
Collection
(cat. 10)

original experience. Significantly, however, he warns that the formation of conceptual knowledge, in being derived from perception, involves a process of abstraction – a 'distancing' – from the world. In his view, 'perception...alone is the unconditionally true genuine knowledge, fully worthy of the name'[9] and he argues: 'Only the poorest knowledge, abstract secondary knowledge, the concept, the mere shadow of knowledge proper, is unconditionally communicable. If perceptions were communicable, there would then be a communication worth the trouble....'[10]

For Schopenhauer, perception is central to our understanding and experience of the world, and it is a more reliable form of knowledge than those concepts that are 'derived' from our perceptions. For that reason, as a source of truth and wisdom it is to our perceptions that we must turn. This is a bold imperative from a philosopher whose discipline is rooted in the formation of abstract concepts. Schopenhauer acknowledges the ease with which concepts can be communicated – in the form of spoken or written argument – but, even so, concepts are a poorer form of knowledge, weakened by being 'abstracted' from experience. The problem he identifies with perceptions is that, because they are immediate and fleeting, they cannot be retained, and they therefore cannot be communicated. His plea – 'if perceptions were communicable' – has enormous significance in relation to Riley's art.

Nature

The pleasure of looking at nature during her childhood informed Riley's visual sensibility, and the imperative to create visual pleasure is her stated purpose as an artist. However, she observes: 'the pleasures of sight have one characteristic in common – they take you by surprise. They are sudden, swift and unexpected. If one tries to prolong them, recapture them or bring them about wilfully their purity and freshness is lost.'[11] There is a sense that, for her, the depiction of nature in the form of literal images would be a form of abstraction – of distancing – from the original experience. Rather than conveying the content of an actual, present experience, the pictorial imitation of a subject in nature would serve only as an attempt to prolong or recreate an earlier visual experience of the appearance of such subjects. In other words, a literal image stands at one remove from the original experience – just as in Schopenhauer's philosophy a concept is a 'mere shadow' of the experience from which it was derived. For Riley, the pleasures of sight cannot be communicated in the form of literal images. Rather, such singular visual experiences are real, immediate and happen in the present. They cannot be stored or recreated. They exist as a 'perfect balance between the two, between the inner and the outer'[12], that is to say, in perception.

It is for this reason that in order to create visual experiences which approach the force and veracity of those found in nature, paradoxically Riley's art withdraws from the literal depiction of the external world. Instead of reproducing the appearance of recognizable subjects, she offers the viewer elements which are irreducibly real in themselves – simple shapes and colours – to which the eye and psyche can respond directly. It is one of the marvels of her art that an encounter with one of her early paintings not only invites a direct and immediate perceptual experience, but that in such encounters, at the same time, the experience of seeing is, itself, made apparent.

Riley's art is singular in that its means of communication – the medium – is not limited to its physical constituents. Her early paintings, in particular, cannot be described solely in terms of their surface characteristics. Rather, their true character is revealed only as they are experienced. It would be meaningless, for example, to attempt to describe *Descending*

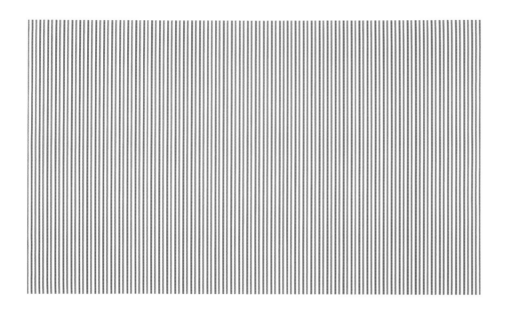

Late Morning
1967–8
Tate
(cat. 15)

1965, in terms of an arrangement of zig-zag lines, as if that was what the painting was about. The work's nature is, in a sense, 'contained' in these ostensible surface characteristics and only made apparent in the viewer's responses to the sensations solicited by the painting's physical features. Even at this perceptual level, however, its character remains elusive: people see her work differently. Some focus on the bolts of light that appear to course across its surface. Others follow the implication of physical movement. The appearance of peaks and troughs is, for some, the primary experience. In some instances, light is perceived as colour. The painting is all of these things, and perhaps none of them. What Riley offers is a perceptual experience which remains fundamentally private and essentially unique to the viewer. It is as if to say perception is the closest we can get to the true nature of the external world: it is not the world itself, but our inner response to it. Perception is, however, all we have.

Until 1966, Riley probed the new medium of perception, using black, white and grey and a range of simple elements – squares, circles, ovals, lines, stripes and curves – disposed in different formal arrangements. With these limited means, she disclosed an astonishing variety of visual experiences: not only movement and light, but events that range from a sense of visual compression and opacity to the appearance of sudden convulsion – almost like a shiver or tremor. Throughout her investigation of this territory, perception itself is an insistent presence, not only yielding these experiences, but drawing attention to itself as the agent responsible.

Light

From 1967, when she first introduced colour, the emphasis shifts. It is as if the grammar of perception has now been defined, the point made. Its 'overt' presence therefore recedes.

In her exploration of colour and its relation to light, perception is still an integral element, but it is now fully absorbed into the experience of her work. This development is also due to the entirely different character of colour. The central principle of the black and white works was one of 'repose, disturbance, repose.'[13] A stable formal situation – a shape or progression of shapes – would be stated, then destabilized by modifications to that shape or progression, then the original shape or sequence would be reasserted. Destabilizing a shape, or disrupting a regular formal sequence, was an essential step leading to the intense perceptual experiences that resulted. However, as Riley now recognized, the perception of colour is 'inherently' unstable. There is no possibility of setting up a stable situation because the experience of any colour is entirely relative: its appearance and behaviour depend on its context. In perceptual terms, every colour affects, and is affected by its neighbour. The basis of her work in colour is therefore 'continuous' instability.

Significantly, the interaction of different colours is perceived as an impression of light. This is apparent in *Late Morning* 1967, one of her earliest essays using colour relationships. As in her black and white paintings, the work consists of a progression of simple shapes. In this case, the formal argument comprises narrow vertical stripes, the purpose of the stripes being to facilitate the interaction of adjacent colours. These bands are of constant width, in three main colours – red, green and blue – on a white ground. The red remains constant, but by modulating the values of the blue (so that it progresses towards turquoise) and the green (progressing towards yellowish green), the resulting optical fusion is responsible for the impression of a soft, golden haze flooding the field of vision. This experience is self-evidently perceptual, not least because the viewer is aware that what is seen (tinted light) does not correspond to the original components of that

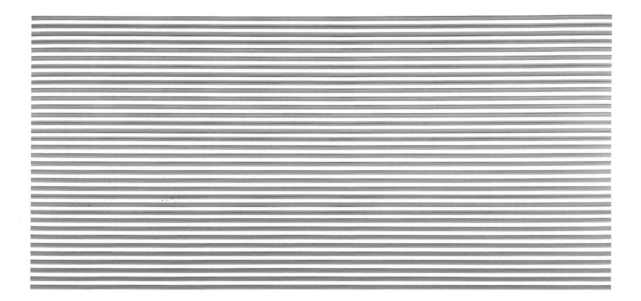

Rise 1
1968
Sheffield
Galleries and
Museums Trust
(cat. 16)

experience (stripes of colour). Even so, the perceiving process does not command attention as a source of interest in itself. Rather, it is now completely unified with the experience of emanating light, and it is this which now presents itself as the main focus of visual pleasure.

Riley's black and white paintings, and her subsequent development of colour from 1967 until 1980, using crossed stripes, twisted stripes and curves, can be seen as two sides of the same coin. These phases of her work are at once continuous, but also different in aspect. Continuous in terms of their common basis in perception. Different in the way that the black and whites assert the principle of 'contrast' – black against white, stability against instability, sensation filling the eye and leading inexorably to often powerful and sometimes disorientating hallucinatory perceptions; whereas the colour paintings advance 'relations' – subtle and often understated connections, a situation of continuous colour interaction rather than formal destabilization, and a build-up from sensation to perception which has a natural and often gentle inevitability.

Vapour
1970
Sheffield
Galleries and
Museums Trust
(not exhibited)

The black and white paintings present perception as a protagonist, driving the action; in the colour paintings, perception is our guide, moving us through an unfolding spectacle. The colour paintings also, as Riley has acknowledged, advance towards nature: 'colour inevitably leads you to the world outside.'[14] No less abstract, in formal terms, than their monochrome counterparts, the visual experiences they offer nevertheless seem impressed with a sense of heightened familiarity. This is evident, for example, in the horizontal inflections of light on the surface of *Rise 1* 1968, the cool leaf-fresh atmosphere of *Vapour* 1970, and the softly glowing translucence of the *Song of Orpheus* series of 1978.

Such effects are non-descriptive, but evocative – recalling the rhythms and patterns of nature. The curve paintings in particular, on which Riley worked between 1973 and 1980, generate undulating fields of light and movement. They dissolve colour, as if in a rising haze of heat or a rippling current. Such paintings have been identified with a growing serenity, perhaps a growing refinement. This is linked possibly with Riley's adoption of a paler palette, her use of the less formally assertive curves, and a move towards harmonic interaction as opposed to contrast. While there is an element of truth in this – and certainly Riley's paintings at the end of the 1970s appear to radiate a kind of pacific calm – any sense of growing refinement is, arguably, more connected with the degree to which she had resolved the role of perception in her work. By the late 1970s, the experience of her paintings involves a smooth and seamless passage from the initial apprehension of their formal organization, to a progressive accumulation of sensation, and finally to a flooding of the pictorial field with light and movement. In terms of the overall development of her work, there is a sense that investigation has blossomed fully into celebration. However, given Riley's ongoing instinct that simply maintaining a position, however

Song of
Orpheus 3
1978
Private
Collection
(cat. 23)

hard-won, leads to stagnation, continued progress now entailed a return to investigation.

Sensation

In a key passage in *The World as Will and Representation*, Schopenhauer writes:

> To perceive, to allow the things themselves to speak to us, to apprehend and grasp new relations between them, and then to precipitate and deposit all this into concepts, in order to possess it with certainty; this is what gives us new knowledge...The innermost kernel of every genuine and actual piece of knowledge is a perception...If we go to the bottom of the matter, all truth and wisdom, in fact the ultimate secret of things, is contained in everything actual, yet certainly only 'in concreto' and like gold hidden in the ore. The question is how to extract it.[15]

Riley's work from 1961 to 1980 gives a central role to perception. Her paintings manifest an ongoing endeavour to grasp relations between simple 'things' – shapes and colours – and then to build, using those relations, towards perceptual experiences which, in an intangible way, seem uncannily familiar. In this respect, her art approaches, what Schopenhauer movingly describes as, 'the ultimate secret of things.'

After 1980, a fundamental development occurs. Following a trip to the Nile Valley in the winter of 1979–80, when she visited the tombs of the later Pharaohs in the Valley of the Kings, she returned to London suffused with the memory of the five colours she had observed as having been used by the Egyptians in their tomb decoration. At the bottom of her fascination with the so-called 'Egyptian palette' – red, blue, yellow, turquoise and green – was the realization that these same intense colours occurred in all aspects of the Egyptians' daily existence. They were therefore intimately connected, not only with death, but with life. Recreating these colours from memory, her attempts to use the palette in her own work led, however, to a surprising conclusion. Rather than using the new colours as elements in a perceptual argument, she found instead that the palette invited a different kind of organization. She put this in the following way:

> Right up to, and in some ways including, the stripe paintings I used to build up to sensation, accumulating tension until it released a perceptual experience that flooded the whole as it were. Now I try to take sensation and build, with the relationships it demands, a plastic fabric that has no other *raison d'être* except to accommodate the sensation it solicits.[16]

Having mined the quarry of perception for so long, we now witness Riley seeking to extract, from perception itself, 'the gold hidden in the ore'. Her objective is 'sensation': pure, primary visual experience, preceding the structures of cognition – the raw materials, as it were, of human existence. Indeed, Schopenhauer speaks of the relation of perception and the senses in these terms: 'the 'understanding' is the artist forming the work, whereas the *senses* are merely the assistants who hand up the materials.'[17]

Implicit in Schopenhauer's words is the challenge that confronts an artist working at the fundamental level of sensation. Putting aside those structures linked with perception – the stabilizing and destablizing of formal progressions, the sequences facilitating colour interaction – the artist is now placed in the role of the assistant handling the materials: without structures and without understanding, at least at first. The great difficulty is in knowing how to organize these basic elements, how to shape them so that the work of art does not

collapse into the chaos of uncontrolled sensation – or worse, a kind of visual silence.

Interestingly, there are precedents for this kind of artistic dilemma. The later work of Samuel Beckett, for example, evinces a startling progression towards ever greater reductiveness: action and characterization are virtually eliminated, there are fewer words, shorter and shorter texts. *Breath*, which was first produced in 1969, took this to an extreme, consisting simply of a stage littered with rubbish, the sound of a cry, then breathing, another cry, then silence. With this work it appeared that the writer had effectively written himself into oblivion. Yet subsequent texts by Beckett deny the silence which forever threatens to engulf them. They achieve this through the use of self-regenerating devices, notably repetition and permutation, applied to the basic elements of the texts themselves, as a way of continuing and developing. There are numerous examples, but the following extract from *Rockaby* (1980) makes the point:

V: *Her recorded voice.*

V: till in the end/the day came/in the end came/close of a long day/when she said/to herself/whom else/time she stopped/*time she stopped*/ going to and fro/all eyes/ all sides/ high and low/ for another/another like herself/ another creature like herself/ a little like/going to and fro/ all eyes/ all sides/ high and low/ for another/ till in the end/ close of a long day...[18]

By repeating certain phrases and varying the context in which they recur, the text not only continues but builds to a structure of great expressive density, underpinned by a kind of musical complexity.

The paintings that Riley began to make in the early 1980s also employ quasi-musical devices such as repetition, inversion and variation as a means of drawing the stripes – the individual units of sensation – into a coherent, developed structure. *Silvered* 1981, for example, uses simple colour progressions in different combinations as the basis for an intense and visually rich composition. A brief quotation, moving from the extreme left of the painting, makes this point apparent. Blue, red, green, yellow, blue, red, blue is a kind of opening phrase. A black stripe acts as a break. Then the phrase is repeated in the form: red, green, yellow, blue, red, followed by white pause, and so on. This is not to suggest that some programme or system is in operation here. The basis of this new approach is intuitive and empirical. Indeed, if anything, Riley seems more open in the way the paintings are structured. She no longer accumulates sensation to a particular perceptual end, but is allowing, as Schopenhauer would say, 'the things themselves to speak.'[19]

This way of working, an approach rooted in the organization of sensation, has been the basis of Riley's work to the present day. Increasingly, the paintings have been

structured in regard to 'plastic' considerations. As a result, the development of her art during this period has seen the evolution of entirely new structures. These, in turn, have accommodated and generated an ever-broadening range of sensations – weight, density, opacity, open and closed space and, most recently, movement. In 1986 she deliberately began to disrupt the pronounced vertical register developed in the Egyptian paintings, by introducing a diagonal counter-movement. The effect of this was dramatic. It shattered the surface into myriad lozenge-shapes, which now functioned as smaller, discrete units of sensation. A greatly expanded range of colours fostered the impression of a complex mosaic, without recognisable subject – instead, the fabric of a strange, ineffable deep space which the eye can explore and inhabit. As with her colour stripe and curve paintings of the late 1960s and 1970s, the visual experiences generated by the lozenge paintings seem familiar. The gaze moves from passages of cool shade to blinding brilliance, traversing a space that offers places of rest as well as visual excitement. But, at the same time, this is a kind of place like no other – an infant's world of chromatic refraction, without objects, advancing and receding, responsive to the eye of the beholder.

Since 1997, Riley has pursued further the pictorial implications of the space she had created in the lozenge paintings. By introducing segments of curves, and again restricting her range of colours, the recent paintings now advance toward an extraordinary state of nothingness – no surface, no definite planes, no spaces and, yet, at the same time, *all* of these things. The paintings are only planes of colour, but in flux: constantly shifting and shedding their significance. *Evoe 3* 2003, for example, is a magisterial expression of this latest phase in Riley's art – a tissue of interpenetrating shapes and colours, weaving the space that they simultaneously occupy. The imperative to 'grasp new relations', referred to by

Schopenhauer, here finds expression in an art of pure relation.

One of Riley's most recent works, *Painting with Two Verticals* 2004, offers an intriguing glimpse of where this may lead. Once again, the structure has developed. By reasserting the verticals at the centre of the painting, the abstract architecture of space is asserted – and simultaneously conjoined with the implication of organic form. These two vertical elements are poised, precisely and ambiguously. The mind reaches out to apprehend an image that lies just beyond its own structures of comprehension, and, in so doing, the painting returns us to that state of innocence which precedes the dawn of perception.

Footnotes

1 Emanual Kant, *The Critique of Judgment* (1790), translated by Werner S. Pluhar, published by Hackett, USA, 1987, p. 173.
2 'The Pleasures of Sight' (1984), reprinted in *The Eye's Mind: Bridget Riley, Collected Writings 1965–1999*, ed. Robert Kudielka, London 1999, p. 32.
3 'Perception is the Medium' (1965), reprinted in *The Eye's Mind*, p. 66.
4 'The Pleasures of Sight' (1984), *The Eye's Mind*, p. 32.
5 Interview with David Sylvester (1967), reprinted in *The Eye's Mind*, p. 70.
6 Ibid, p. 73.
7 'The Pleasures of Sight' (1984), reprinted in *The Eye's Mind*, p. 30.
8 Ibid, p. 74.
9 Arnold Schopenhauer, *The World as Will and Representation* (1851), translation in two volumes by E.F.J. Payne, republished by Dover Publications, New York, 1966, p. 77.
10 Ibid, p. 74.
11 'The Pleasures of Sight' (1984), reprinted in *The Eye's Mind*, p. 32.
12 Ibid.
13 'Perception is the Medium', reprinted in *The Eye's Mind*, p. 30.
14 Bridget Riley, *Dialogues on Art*, 1995, p. 70.
15 *The World as Will and Representaion*, p. 72.
16 'According to Sensation: In conversation with Robert Kudielka' (1990), reprinted in *The Eye's Mind*, p. 116.
17 *The World as Will and Representaion*, p. 99.
18 Samuel Beckett, *Rockbaby* (1980), reprinted in *Samuel Beckett, The Complete Dramatic Works*, London 1990, p. 435.
19 *The World as Will and Representaion*, p. 72.

1

Movement in Squares 1961
Tempera on board
123.2 × 121.3 cm / 48½ × 47¾ in
Arts Council Collection,
Hayward Gallery, London

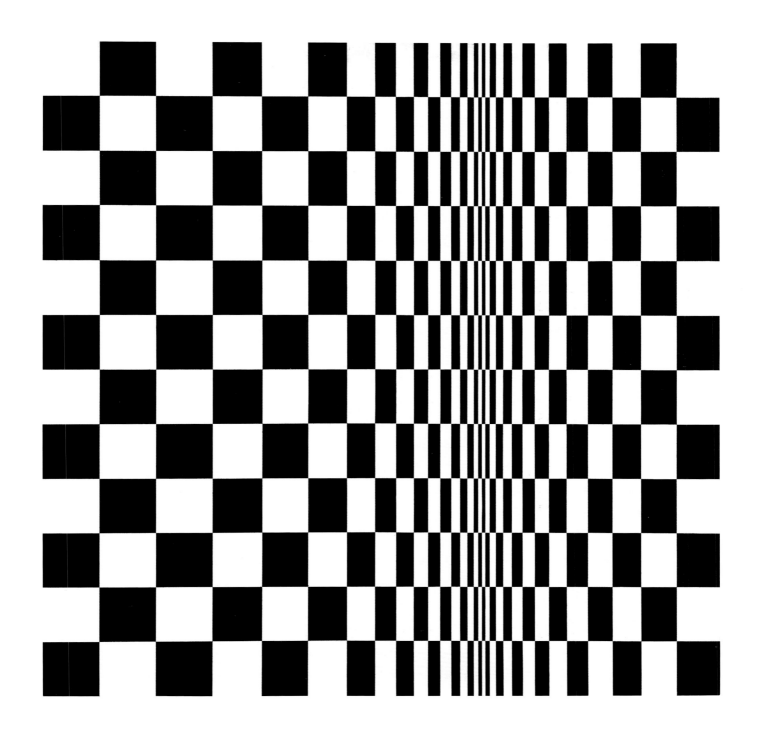

2
Opening 1961

Tempera and pencil on composition board
102.6 × 102.7 cm / 40 × 40 in
National Gallery of Victoria, Melbourne
Felton Bequest 1967

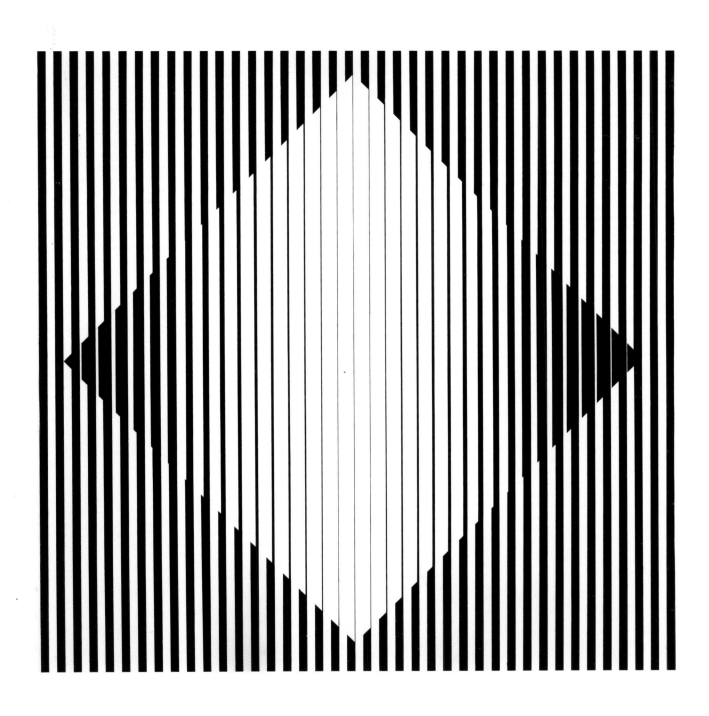

3
Black to White Discs 1962
Emulsion on canvas
178 × 178 cm / 70 × 70 in
Private Collection

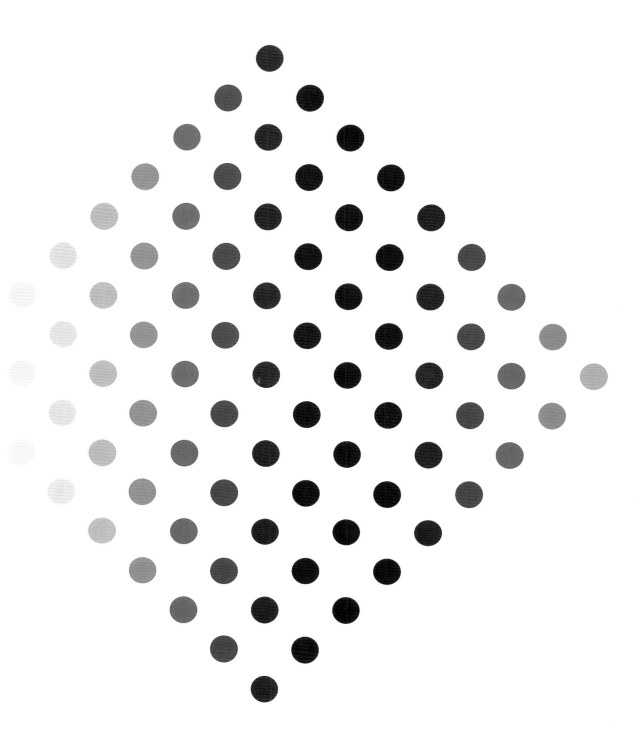

4
Tremor 1962
Emulsion on board
122 × 122 cm / 48 × 48 in
Private Collection

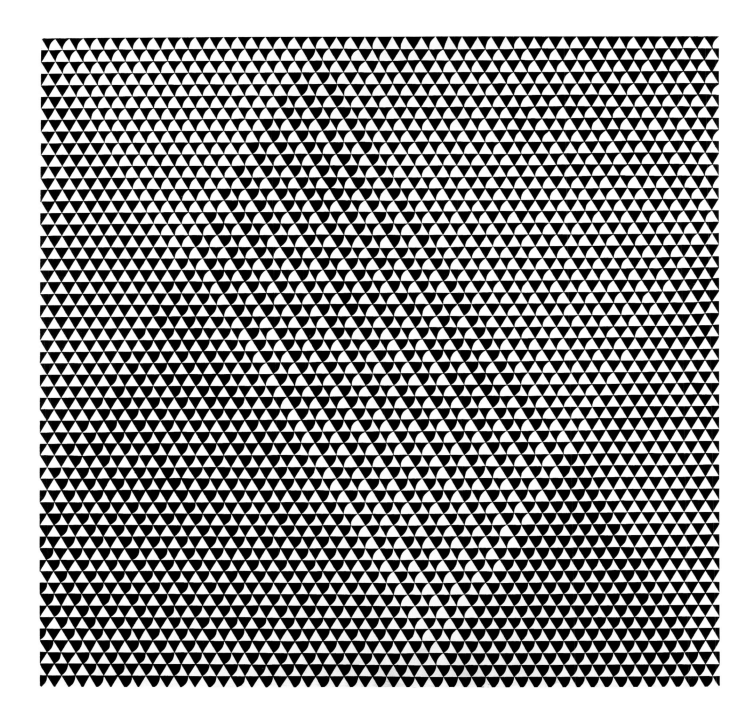

5
Blaze 1 1962
Emulsion on board
109 × 109 cm / 43 × 43 in
Private Collection

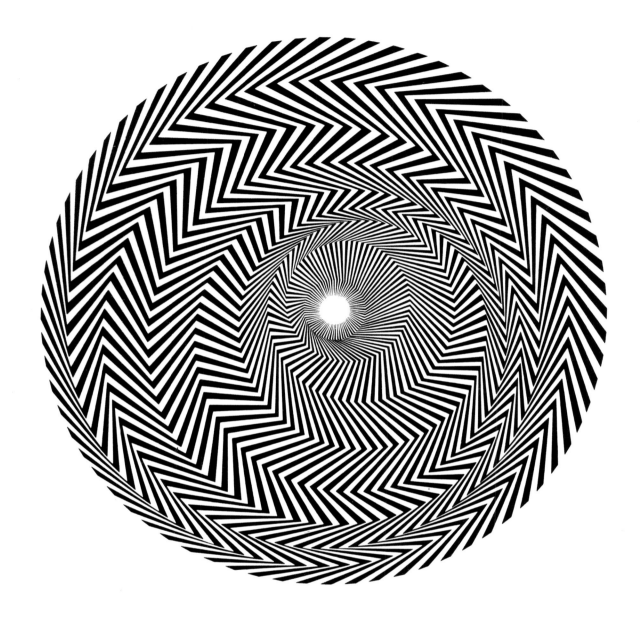

6
Dilated Centres 1963
Acrylic on linen
170.2 × 170.2 cm / 67 × 67 in
Private Collection

50
Study: '65 (Study of Triangle Mutation) 1965
Pencil on graph paper
71.1 × 102.4 cm / 28 × 40¼ in
Collection of the artist

39

Cartoon for *Blaze* 1962
Pencil and scotch tape on paper
94.5 × 94.5 cm / 34¼ × 34¼ in
Collection of the artist

48
Study for *Burn* 1964
Gouache on graph paper
39.7 × 36.7 cm / 15½ × 14¼ in
Collection of the artist

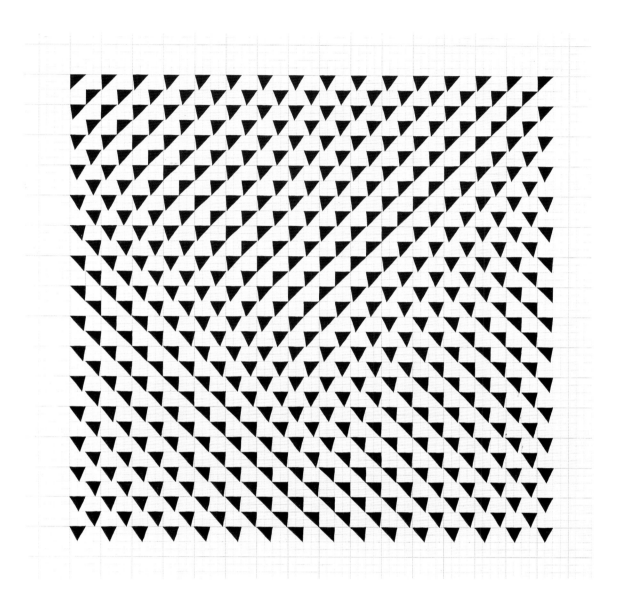

46
Study (*Turn*) 1964
Gouache on graph paper
46.5 × 46.5 cm / 18 × 18 in
Collection of the artist

7
Burn 1964
Emulsion on board
56 × 56 cm / 22 × 22 in
Private Collection

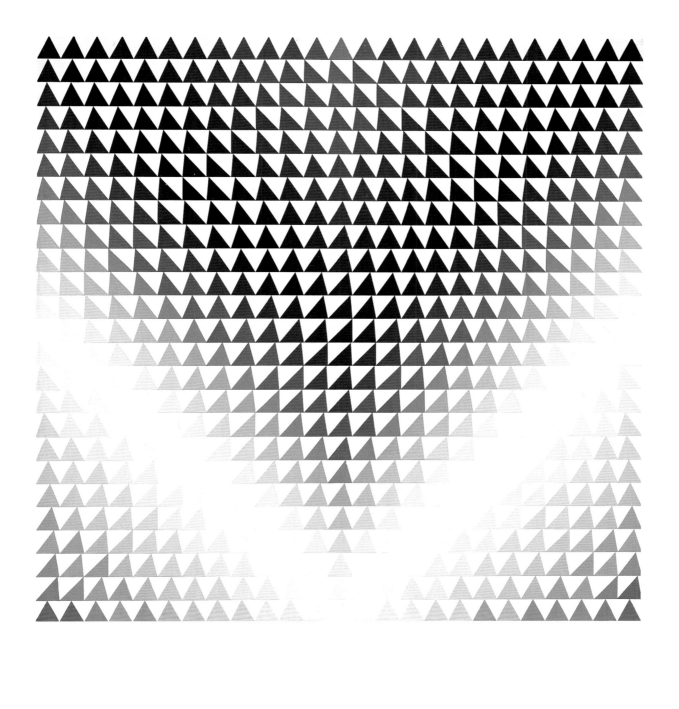

8
White Discs 2 1964
Emulsion on board
104 × 99 cm / 41 × 39 in
Private Collection

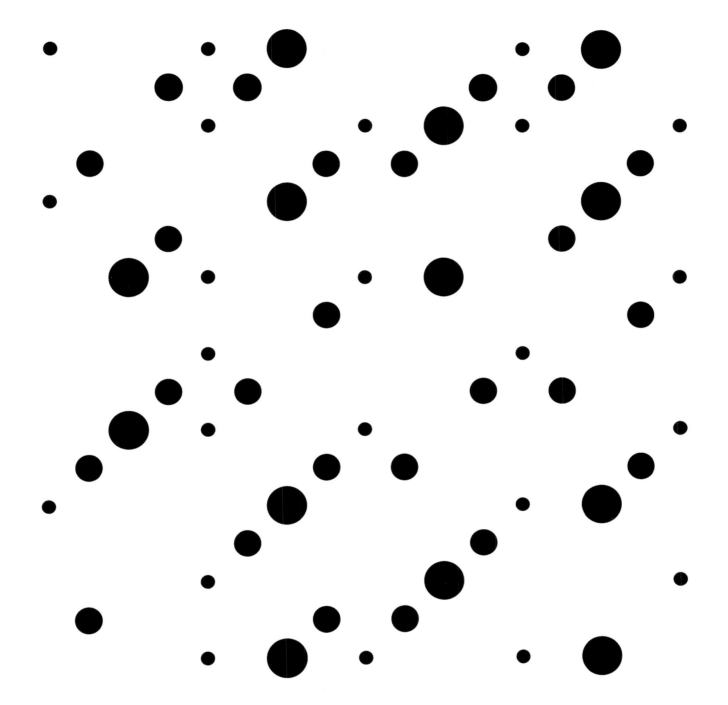

9
Crest 1964
Emulsion on board
166.5 × 166.5 cm / 65½ × 65½ in
British Council Collection

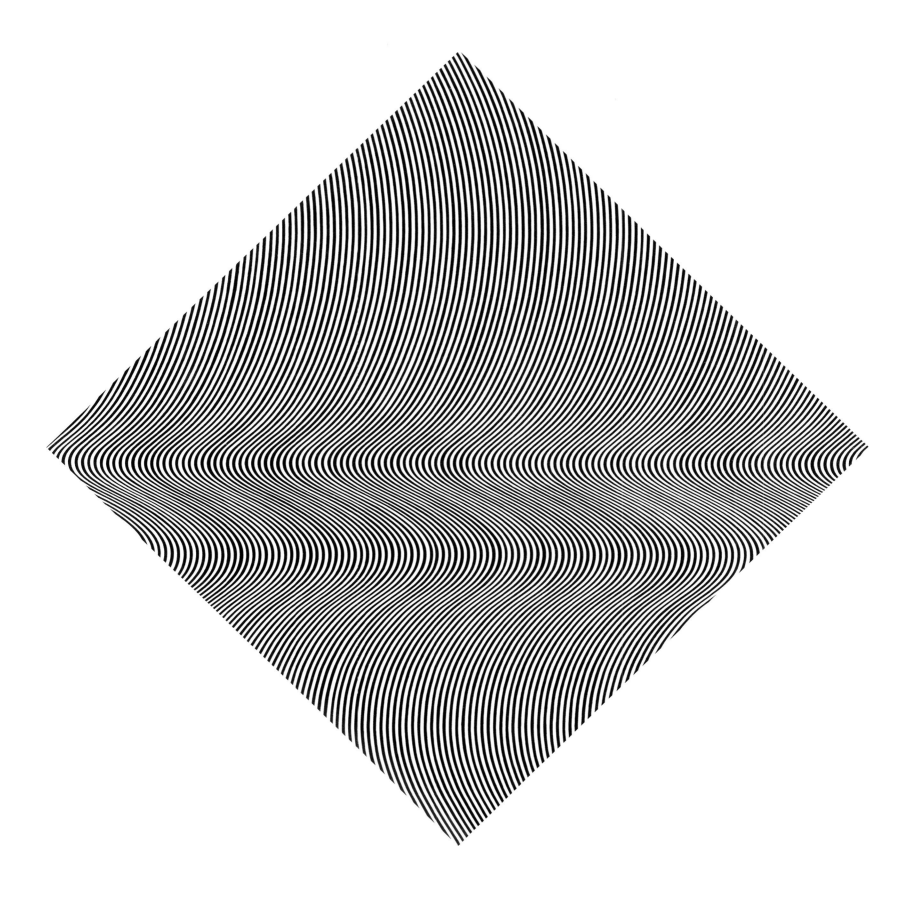

10
Descending 1965
Emulsion on board
91.5 × 91.5 cm / 36 × 36 in
Private Collection

41
Study for *Twist* 1963
Gouache and pencil on graph paper
23 × 34 cm / 9 × 13½ in
Collection of the artist

42
Study for *Twist* 1963
Pencil on graph paper
25.2 × 45.3 cm / 9¾ × 17⅝ in
Collection of the artist

40

Untitled Study 1963
Gouache and pencil on graph paper
88.9 × 114.3 cm / 34⅝ × 44½ in
Collection of the artist

45

Study for *Shuttle* 1964
Gouache and pencil on graph paper
21.6 × 26 cm / 8½ × 10¼ in
Collection of the artist

11
Hesitate 1964
Oil on canvas
106.7 × 112.4 cm / 45½ × 45¾ in
Tate
Presented by the Friends of the Tate Gallery, 1985

12
Remember 1964
Acrylic on board
106.7 × 113 cm / 42 × 44½ in
Kerry Stokes Collection

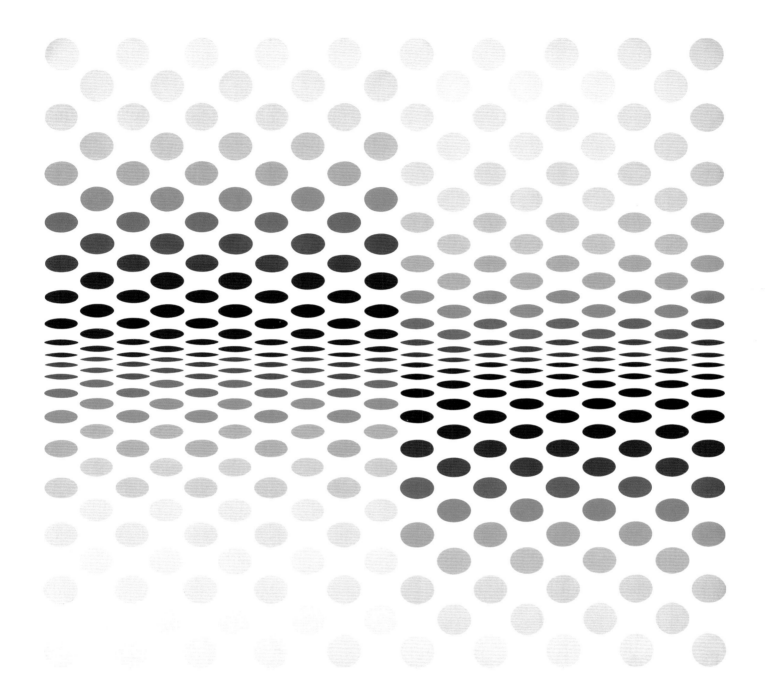

13
Static 3 1966
Emulsion on canvas
163.2 × 163.2 cm / 64¼ × 64¼ in
Museum of Contemporary Art, Sydney
J.W. Power Bequest, purchased 1967

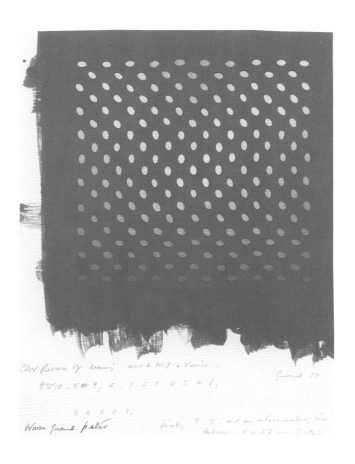

58
Untitled (Study for *19 Greys*) 1966
Gouache on paper
34 × 25 cm / 13½ × 10 in
Collection of the artist

59
Untitled (Study for *19 Greys*) 1966
Gouache on paper
34.5 × 26.7 cm / 13½ × 10½ in
Collection of the artist

<div align="center">

54

Study for *Static* 1966

Biro and pencil on tracing paper

50.8 × 137.2 cm / 20 × 54 in

Collection of the artist

</div>

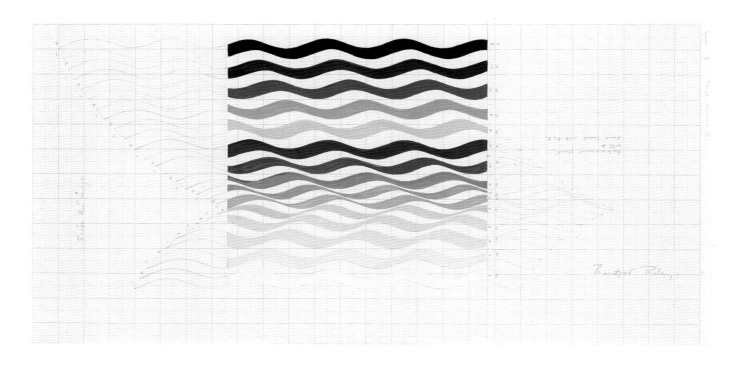

53
Untitled Study for *Arrest* 1965
Gouache and pencil on graph paper
34.3 × 67.3 / 13⅜ × 26⅛ in
Collection of the artist

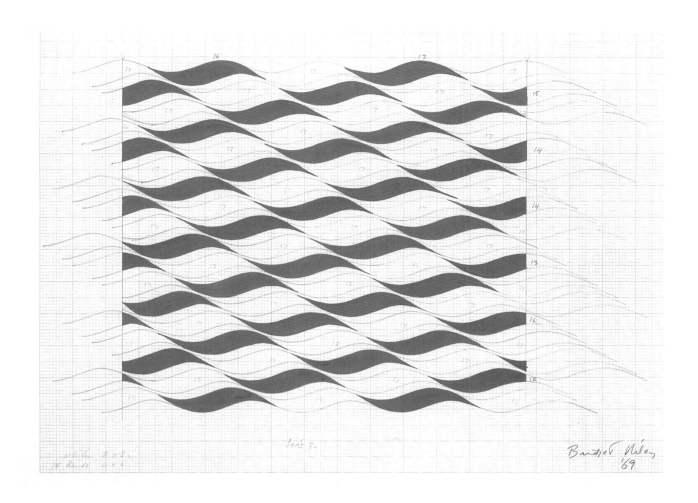

67

Untitled 1969

Gouache and pencil on graph paper

36.1 × 49.5 cm / 14 × 19¼

Collection of the artist

14
Cataract 3 1967
PVA on canvas
221 × 222.9 cm / 87 × 87¾ in
British Council Collection

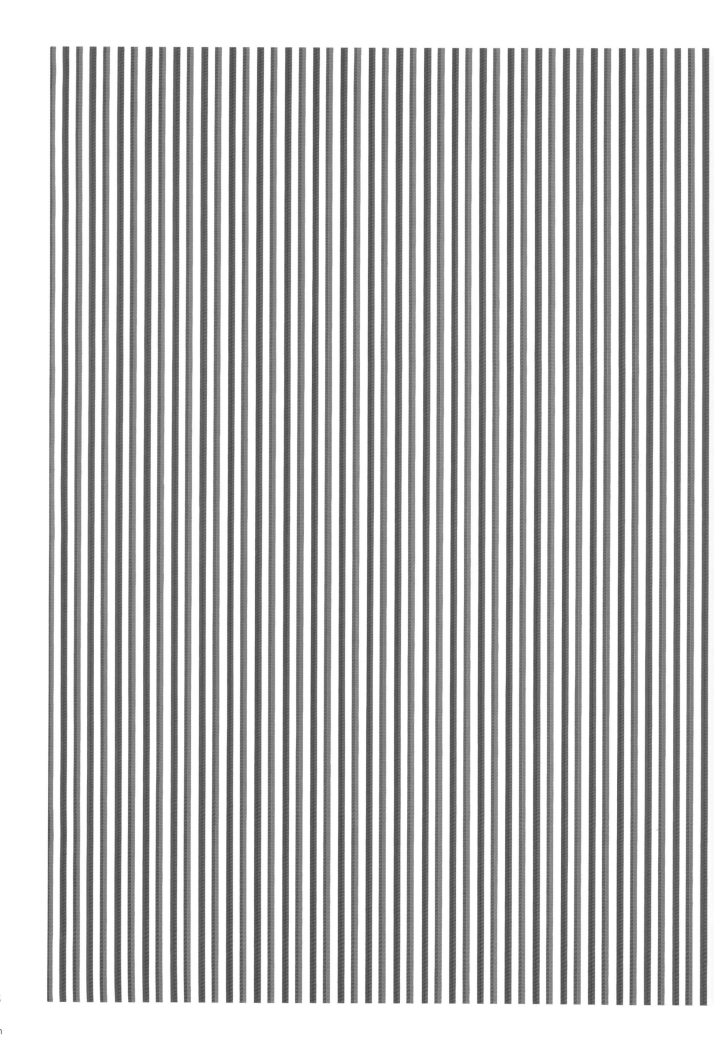

15
Late Morning 1967–8
PVA emulsion on canvas
226.1 × 359.4 cm / 88⅞ × 141⅝ in
Tate. Purchased 1968

65
Study for _Late Morning 2_: Long Sequence 1967
Gouache on graph paper
16.5 × 207.6 cm / 6½ × 81¾ in
Private Collection

64
Three Pairs Organised in Takeover Movement of 3: (Study for *Late Morning 1*) 1967
Gouache on graph paper
17.5 × 71.5 cm / 6⅞ × 28⅛ in
Collection of the artist

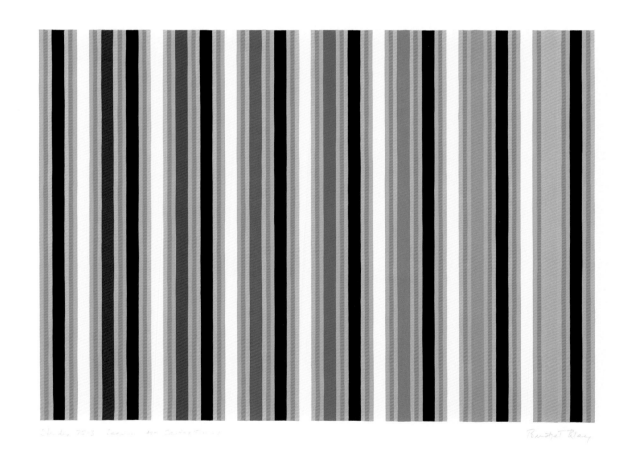

73
Study '72–3: Sequence for *Cantus Firmus* 1973
Gouache on paper
53.3 × 70.5 cm / 21 × 27¾ in
Collection of the artist

69

Scale Study for *Zing 1* 1971
Gouache on paper
101.6 × 38.1 cm / 40 × 15 in
Collection of the artist

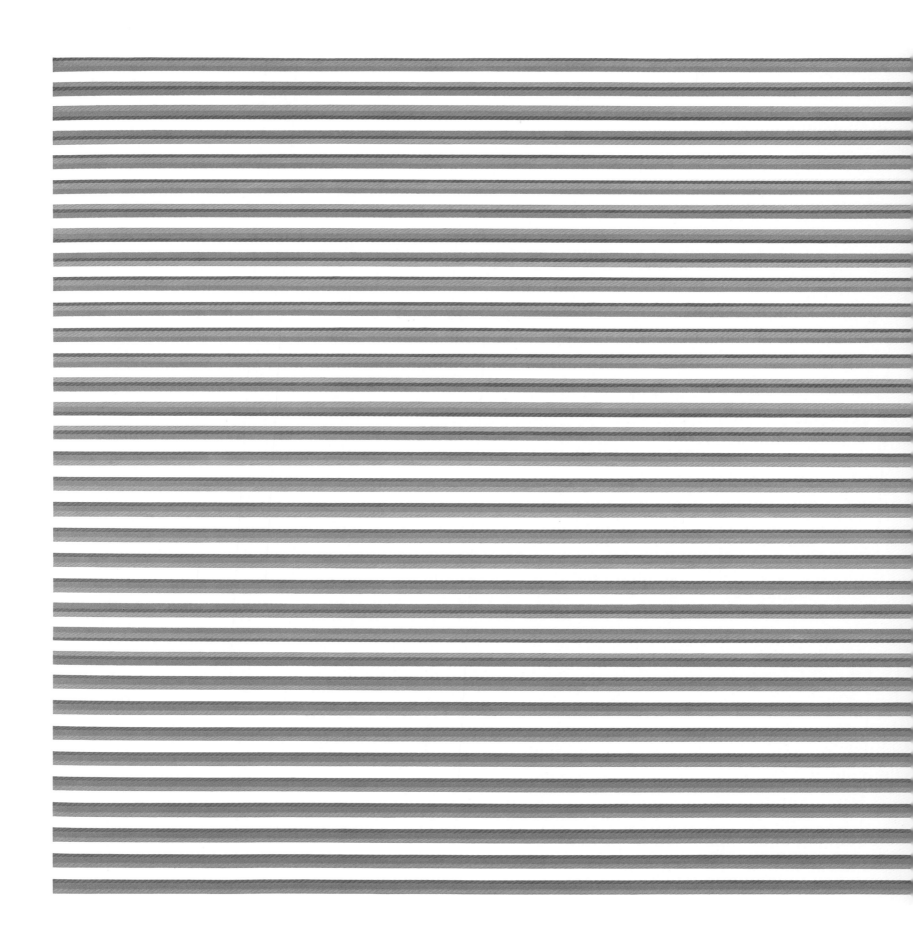

16
Rise 1 1968
Acrylic on canvas
188.2 × 376 cm / 74 × 148¼ in
Sheffield Galleries and Museums Trust

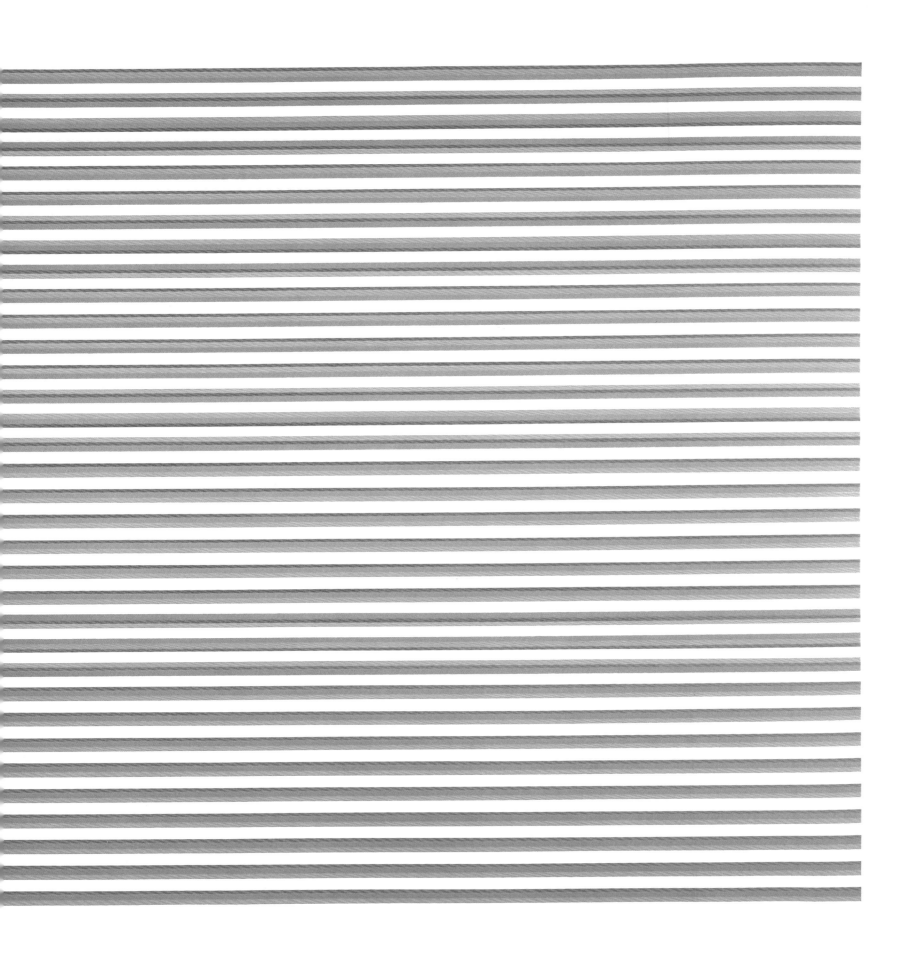

17
Persephone 2 1970
Acrylic on canvas
212 × 168 cm / 85⅝ × 66¼ in
N.M. Rothschild & Sons Ltd.

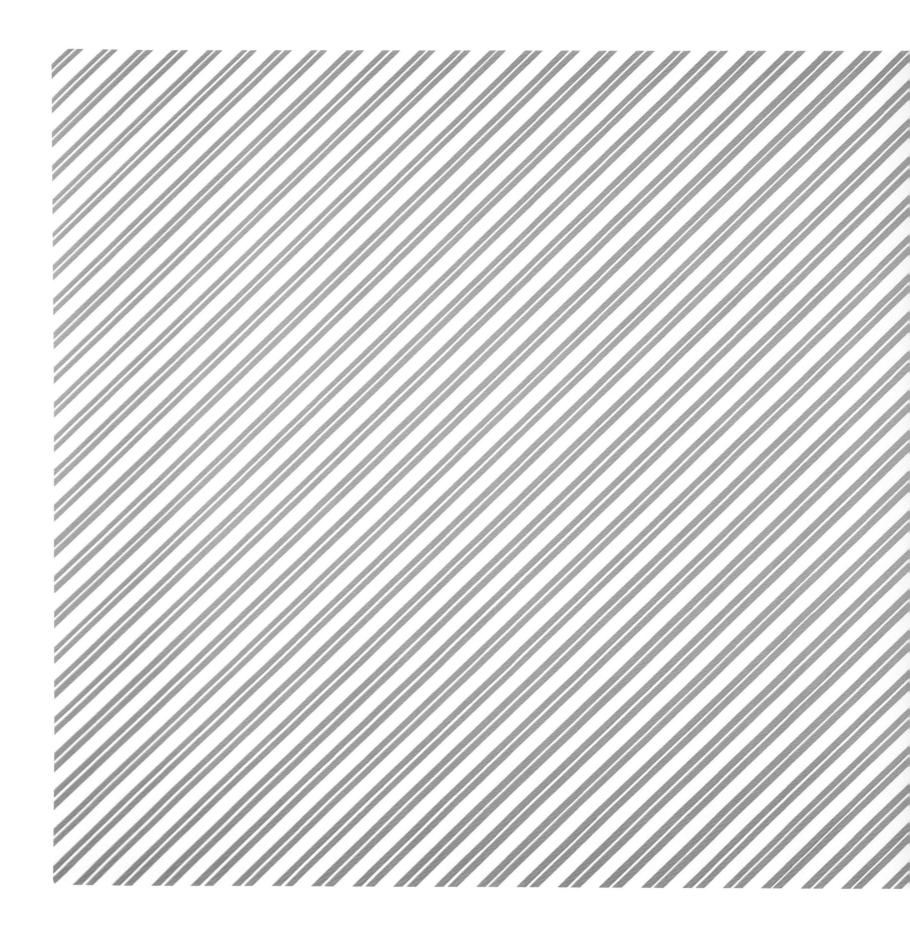

18

Veld 1971
Acrylic on linen
191.5 × 395 cm / 75⅜ × 155½ in
National Gallery of Australia, Canberra
Purchased 1977

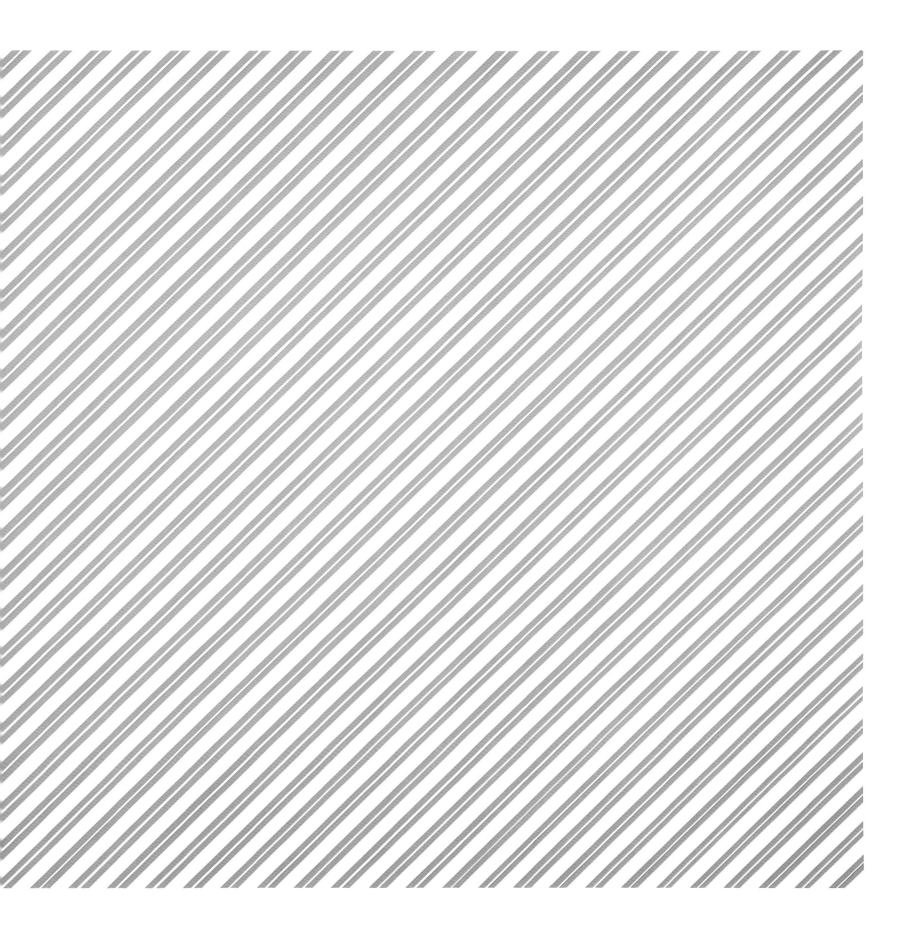

19
Cantus Firmus 1972–3
Acrylic on canvas
241.3 × 215.9 cm / 95 × 85 in
Tate. Purchased 1974

20

Pæan 1973
Acrylic on canvas
289.5 × 287.3 cm / 114¼ × 113⅛ in
National Museum of Modern Art, Tokyo
(not exhibited)

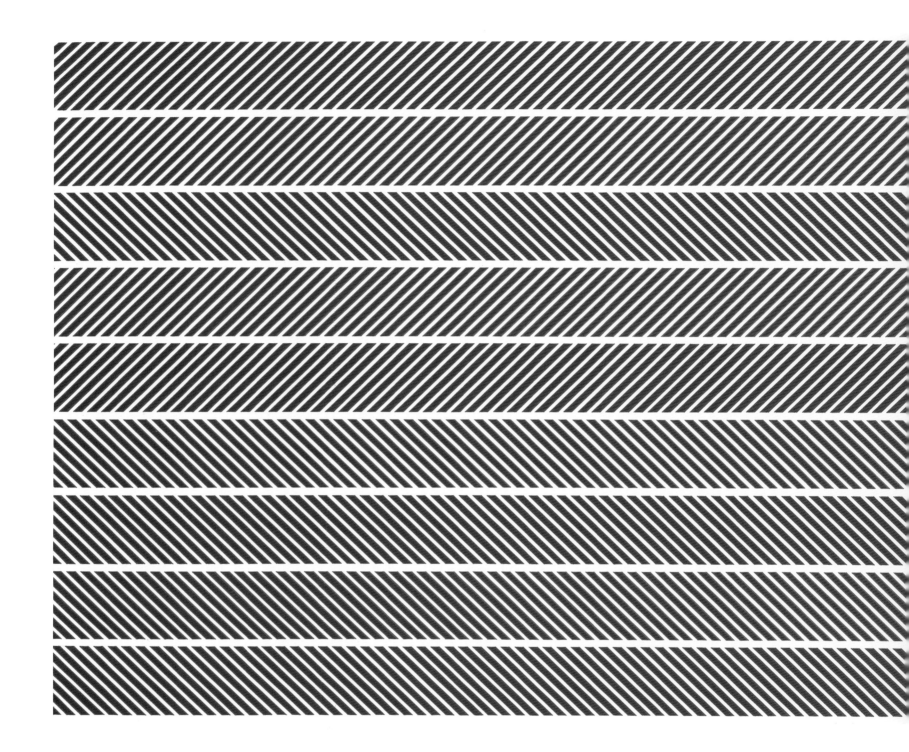

21
Rattle 1973
Acrylic on linen
153.3 × 381.3 cm / 60⅜ × 150⅛ in
Private Collection

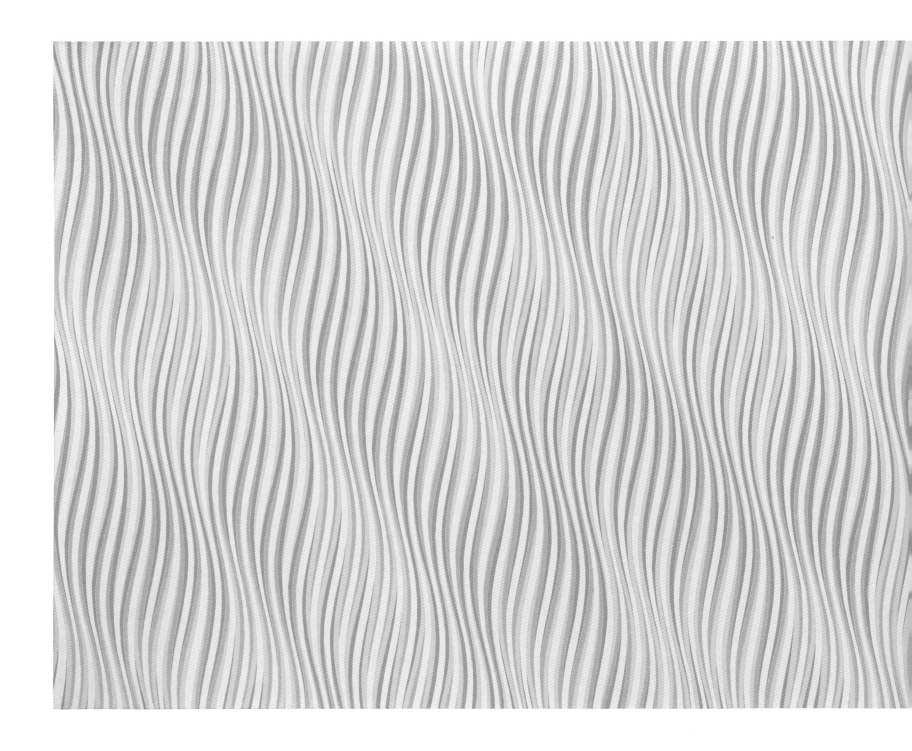

22

Aurum 1976

Synthetic polymer paint on linen

105.5 × 272 cm / 41½ × 107 in

Art Gallery of New South Wales

Purchased 1976

23
Song of Orpheus 3 1978
Acrylic on linen
195.6 × 259.7 cm / 77 × 102¼ in
Private Collection

24
Andante 1 1980
Acrylic on linen
182.8 × 169 cm / 72 × 66½ in
Private Collection

78
Twisted Curves 1977
Pencil on paper
61.6 × 91.4 cm / 24¼ × 36 in
Collection of the artist

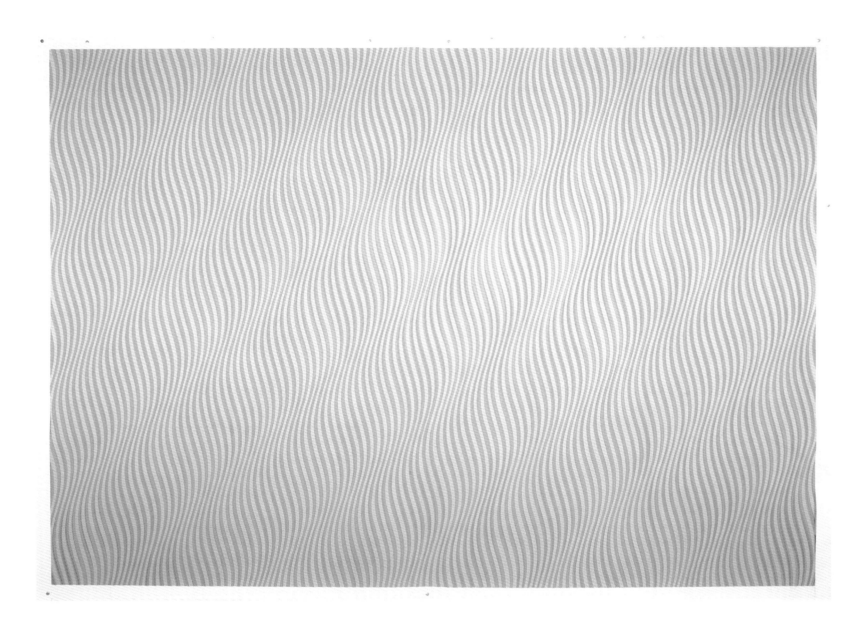

77
Study for *Clepsydra* 1976
Gouache on paper
203.2 × 257.2 cm / 80 × 101¼ in
Collection of the artist
(not exhibited)

79
2 Colour Twist: Blue/Red and Violet/Yellow,
Series 41 – Green added 1979
Gouache on paper
97 × 50.5 cm / 38⅛ × 19⅞ in
Collection of the artist

80
Series 41: Red added – Green and Violet,
Blue and Yellow 1979
Gouache on paper
97 × 50.5 cm / 38⅛ × 19⅞ in
Collection of the artist

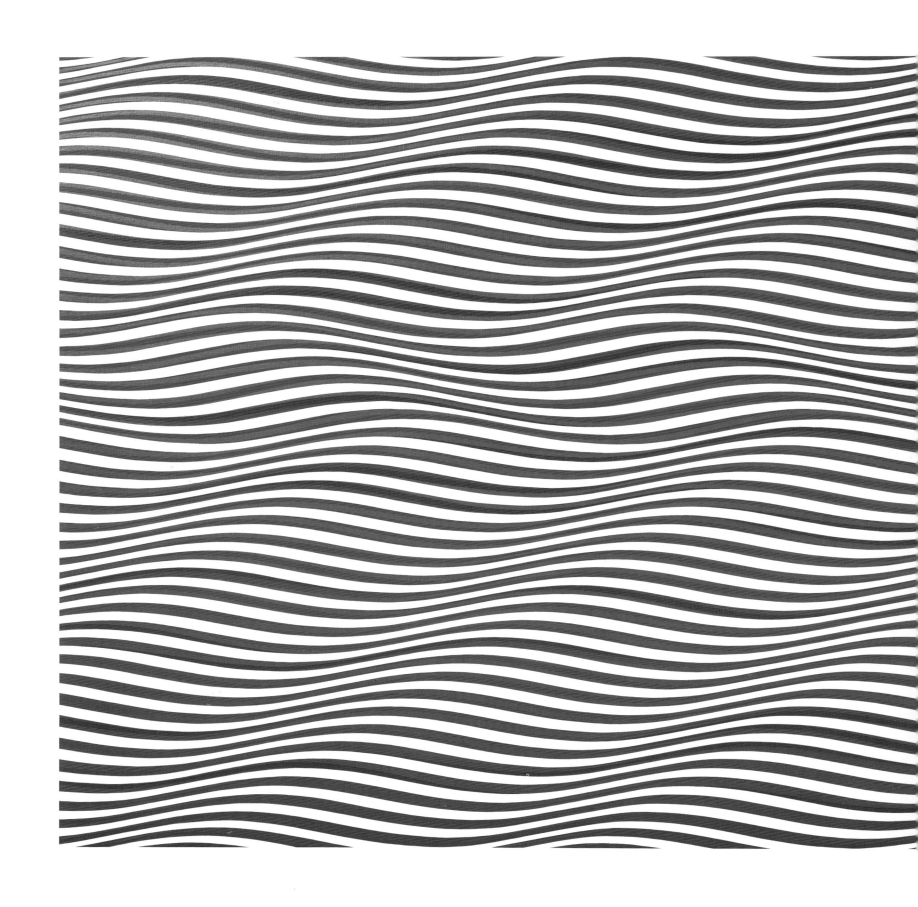

25
Streak 2 1979
Acrylic on canvas
113.7 × 251.5 cm / 45½ × 99 in
Private Collection

Four Colours with Orange 2002
Oil on linen
108 × 251.8 cm / 42½ × 99⅛ in
Private Collection
(not exhibited)

Bridget Riley in conversation with Jenny Harper
April 2004

JH Reflecting on your practice – as a painter who has been working for more than 40 years – it strikes me that, as at the beginning of your professional career, you are a thoroughly modern artist. What do you think were the specific problems of modernity and which issues still interest you?

BR To put it as simply as possible – the dominant feature of the modern era has been a steady dropping away of the old stable hierarchies. This became apparent intellectually in the Age of Enlightenment and simultaneously, on the social front, in the Industrial Revolution. Traditional values and pre-ordained structures were continually questioned, replaced or even abandoned. This process inevitably affected the practice of art. Artists found that they could no longer expect – or be expected – to communicate through a commonly agreed imagery, alternative routes had to be discovered. The experiences and responsibilities of the individual had become important in ways they had never been before. It was – and is still – impossible to retreat from this modern achievement. Only by accepting this situation can artistic insight find echoes and responses in a wider public. But relying solely on one's individual resources is not quite enough. To give your work more than a personal validity you need the support of a more objective framework. Where can one find this if not in the past? I believe that it is possible to rediscover principles and laws in older work quite independently of the styles in which they initially appeared.

JH Another important feature of your approach – and one which is important in the intellectual links you make with modernity – is your admiration of the work of a number of artists from the past. You have been very open about your admiration of individual artists like Seurat and Cézanne, and others such as Poussin, Mondrian and Paul Klee. You've seen yourself as linked to a lengthy tradition and entitled to analyse and take critical advantage of the lessons and stimulations it offers.

BR Yes, I have looked carefully at Seurat, Cézanne and others.[1] To think that I rank myself with such great figures would be a misunderstanding. Above all, I believe that one should not deprive oneself of the pleasure of looking at and appreciating what has been achieved. But as an artist you also want to know more about your practice.

While one has to accept that the role of art and its subjects do change, the practical problems do not. Finding out what is integral to an art form and on what relationships it depends illuminates the problems that may arise and this, in turn, gives you a way of dealing with them. How, for instance, to treat colour, pictorial space, structure etc.? These problems have, of course, been treated differently in different periods, by different personalities, but recognizing the basic issues helps you with your own work. This is where art assumes the role of enquiry. True modern painting, I believe, should always be a beginning – its own re-invention, if you like.

JH You have recently been a visiting professor at the de Montfort University in Leicester and you asked the students there to copy a Mondrian.

BR There were several reasons, really. When I began to teach I had just co-organized (with Sean Rainbird at the Tate Gallery), an exhibition tracing Mondrian's development 'From Naturalism to Abstraction',[2] which was a fascinating task. Checkerboard with light colours (1919, Gemeentemuseum, The Hague) is the painting I asked the students to copy. It came after Mondrian's Pier and Ocean studies made from his memory of walking by the sea at night, seeing the sparkle of the stars above and their reflections in the dark sea. He treated this same sensation in a number of different ways and I wanted the students to see these differences and to understand that such an experience can be expressed in a

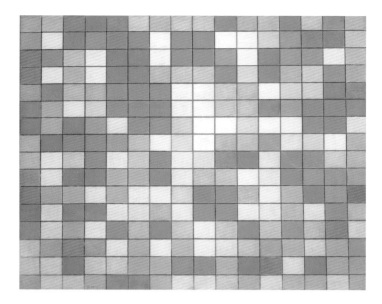

variety of ways, even by the same artist. Another reason was to make clear that making a copy is not simply mechanical but a positive way of assimilating someone else's thinking. You can get closer to another mind through direct imitation. After all this is how we originally learn our own languages. Imitating a work is simply one of the best ways of internalising its artistic logic. As Leonardo said: 'he who can copy can create.' This observation is just as valid today as it was in his own time.

JH *You started with figure drawing and that was very important to you but in this case these students are launching into abstraction...*

BR Not really. Abstraction is fundamental to painting in general. If you are painting a portrait, a figure or a landscape, the colours you have on your palette and which you will have to use on your canvas are inevitably different from the colours you see in the world around you. Similarly, in dealing with the advances and recessions in the picture plane you will be facing a problem far removed from actual physical space. Painting has been an abstract art long before Abstract Art became a style and a theory. I have an assistant, Andrew Smith, who has worked for me in the studio for many years. He is a landscape painter who has successfully tackled difficult subjects such as light falling through foliage because he is capable of organizing this diffuse sensation in a properly abstract manner.

JH *As well as the Mondrian exhibition, you recently organized an exhibition of the work of Paul Klee at the Hayward Gallery. How do you relate to Klee's art?*

BR I worked with Robert Kudielka organizing this exhibition of Paul Klee's work because, like Mondrian, Klee has been pivotal for me. There are different aspects of influence. One can be influenced simply by the appearance of something, or by the possibility of reaching through the appearance to the thinking behind it, as I was with Seurat. At other times one is influenced by the ideas and not the appearance of the work. That was how it was for me with Klee. He showed me what abstraction meant in painting and how to enquire in an artistic way.[3]

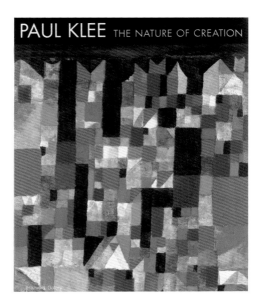

Paul Klee
Cover of Hayward
Gallery exhibition
catalogue
2002

Damien Hirst
Apotryptophanae
1994
Household gloss
and emulsion on
canvas

JH *Mondrian is an artist who consistently worked within particular limitations. Like him, you have always felt it was important to be constrained rather than be totally free. I was thinking again of our conversation about the poet Gerard Manley Hopkins and the way he felt constrained but also profoundly liberated because of this constraint.*

BR I was amazed by his modernity. Recently I was given a book of his poetry and prose notes, with a very good introduction by Walford Davies.4 Hopkins deliberately uses words as *things*, talking of the *thingness* of the word. He wanted his poetry to be read aloud, so that the patterns and rhythms of stresses on vowels and alliteration became virtually abstract *things* to work with. As he went on he subjected words to tighter, more complex disciplines. But this strict formality was eased and brought to life by his love of nature. Sadly he destroyed much of his early work, feeling that his pleasure in nature was an indulgence and incompatible with his vocation as a Jesuit priest. Fortunately, he came to see that his feeling for God was echoed in the natural world, and that for him celebrating the natural world in verse was a way of praising his Lord.

JH *That is very similar to the way you describe the early impact of your walk in Cornwall, your love of the countryside around Les Bassacs, your observations of nature, the blossom, the tiny irises...*

BR I felt I knew Hopkins. But I did not have his moral inhibitions towards pleasure in nature. The problem I had was when I realised that any direct depiction of Cornwall would not express what I felt about being there.5 How do you convey the freshness of a walk across the cliffs in the early morning, the blackness of the sea in deep shadow or the shiver of tiny grasses blown by the wind? I wanted to recreate such sensations – and this longing has shaped and still informs my understanding of abstraction. I start at the other end, so to speak, prepared to find sensation – en route to a painting.

JH *Your own work is being embraced and looked at freshly by a younger generation. Postmodernism has made much of the affinities between contemporary art and the art of the past, as well as the relationships between fine art and popular culture. In the early 1960s your work was plagiarised for fabric designs. You were clear that this was wrong, that you felt violated by it.*

BR I think there is a tremendous difference between artists imitating or even directly copying one another, and something primarily done for commercial purposes, which the dresses were. One is about learning and understanding, the other a rip-off and a trivialisation.

JH *Younger painters such as Philip Taaffe have also copied your work, and others like Damian Hirst acknowledge and pay homage to you more obliquely in theirs. Even the New Zealand artist Peter Robinson has made works reminiscent of your Uneasy Centre (1963). In a sense you occupy a very different space in the mind of these young artists.*

BR I thought Philip Taaffe missed the point. My work did not need to have content pumped in by washes of colour and personal marks. He seemed to think that he was supplying something that was missing whereas I had deliberately rejected that kind of painterly handling in order to speak more clearly. He did not even try to 'appropriate', that is to say make something his own. I visited him and offered to show him how to make a curve, but he wasn't interested in that. He simply adopted somebody else's imagery in order to re-edit it with his own garnish.

JH *Perhaps now artists are borrowing in a lighter way, making reference to the visual images they admire, works by artists that mean something to them and have a resonance with the problems they face. I think a number of artists remain fascinated by your practice.*

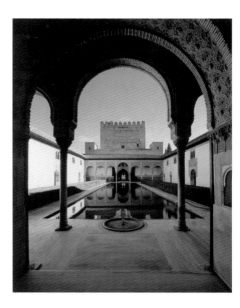

View of the Court of the Myrtles looking towards the Comares Tower. The Alhambra, Granada, Spain

Polychrome glazed panel in the Hall of the Ambassadors. The Alhambra, Granada, Spain

BR I am thrilled to have this response. However, I continue my own practice despite Postmodernism. I acknowledge that the concept of 'appropriation' allowed a renewed moment of reception for my work. It is true that Appropriation Art had a point in opposing exaggerated notions of novelty in Modernism, but it seems to have run out of purpose and impetus. Unfortunately it failed to re-establish a positive attitude towards copying and the art of the past, it probably had more to do with the widespread fear that artistic invention has dried up. The only answer to this sort of depression is working – steady working.

JH *I'm intrigued that you are including working drawings and collages in this exhibition. Have you come to accept that they're interesting in their own right and that they help others understand your work?*

BR Yes, I have. That's exactly what has happened: the studies aid accessibility. I don't want there to be anything mysterious about the way that I work. I mean there is doubt and uncertainty, and the very act of enquiry means that things go wrong and have to be changed and revised. But to me this is part of the pleasure of working.

JH *Showing your working drawings and collages is also a way of demonstrating how very 'unscientific' your work is, that it's imaginative and in a constant state of flux. Scientific experiments and artistic experiment are of a different nature, which is revealed with these preparatory works.*

BR Well, I hope that it can clarify those sorts of differences. Enquiry is certainly not a question of proof or demonstration, although certain fundamental principles may emerge. Each work exists on its own terms and the relationships that make it up are always unique to each piece. The spirit of enquiry points the way. It can also develop one's powers of recognition so that one can see what one is doing more clearly – what used to be blind

intuition is now conscious intuition. I think that intuition in its best form is conscious.

JH *Visits to different parts of the world have been important for you, from the Egyptian tombs to India. I wonder if we could talk about your appreciation of Islamic art and architecture, particularly since your recent visit to the Alhambra.*

BR I experienced a strong feeling of pleasure being in some of those courts – the tiling, the patterning, was fascinating. I began to realize that the artists had spent a long time analysing how these intricacies might be geometrically layered, but then the best pieces elaborate themselves into pure perception, letting off clusters of colour sensations, of dynamics that seem to loose their moorings completely from the structures that gave rise to them. And, of course, this becomes a contemplative act; it grows slowly, not yielding itself in one glance – contemplation is certainly built into one's appreciation of the Alhambra.

JH *Is that contemplative quality something you wish your own work to have?*

BR Yes, and it has a bearing on something that happened recently. I gave a talk on my work at the Rhode Island School of Design and there were some very interesting questions at the end. One student asked me about the spiritual. I hadn't prepared myself for a question like that, but I found myself saying if, as in Abstract painting, line, colour, space and shape are freed from the service of description, from function in an applied sense – then there may be a parallel in the intellectual sphere. When our mind is freed from the need to apply itself to something – to the practicalities of life so to speak – we may open our intellect to a wide range of speculative activities, as 'use-less' in their practice as those found in the nineteenth-century definition of Fine Art. Following along these lines I said my main activity in the studio is the exercise of judgement – pure

judgement. It could be said that it is my intellectual 'mode' or form of thought when I am working, and can properly be called 'pure' because like pure colour, such judgement is distinguished by having no referential role outside the work itself. It seems that many people feel that there is something 'there' in good Abstract painting that can neither be assessed objectively nor dismissed as mere mystification. Think of Mondrian – or the Alhambra. Ad Reinhardt regarded Islamic architectural decoration as an origin of Abstract Art. After we met at the *Responsive Eye* exhibition in 1965 he wrote to me, in his inimitable handwriting: 'YOU KNOW, DON'T YOU, WE BELONG TO SOME FAMILY OF ARTISTS, SAME ONE, NOT CHINESE OR INDIAN OR JAPANESE OR ITALIAN, MAYBE MUSLIM, THAT NON-FIGURATIVE ARAB AND PERSIAN CROWD.'

JH *When we spoke yesterday about the diagonal series, those rhomboid paintings you were working on from the late-1980s to the mid-1990s, you said that there was a moment where you felt your work had reached a particular point of freedom, but you decided against pursuing it.*

BR I think that good work needs an internal resistance – it has to set up a tension within itself. I don't think one can ever make what you might call real progress in a situation of total freedom. That's why in the late 1990s – when I used the curve again which I'd always found a stimulating element – I returned to using a smaller range of colours. I incorporated the curve to the diagonal grid I had previously been using. This threw up a whole lot of new shapes to work with and released certain rhythms that I hadn't been able to use before. These were very good experiences, encouraging, affirming.

JH *And it must be wonderful to achieve this sense at this stage in your career.*

BR Yes, it is. When I showed my painting *Rêve* (cat. 36) to the critic David Sylvester he immediately thought of Matisse – and in a sense, he's right. David said, 'It isn't a bit like Matisse, but I think it's an avenue that you would not pursue were it not for Matisse. There seems to be more than one way out of Matisse.' Recently I have been relying more on the feeling of the work. I am surer of my feelings when I work and allow these to prompt what I am doing. And once more there is the paradox – I have found a stricter foundation results in greater freedom.

Les Bassacs, Provence

Footnotes

1 Riley has discussed her relationship to Seurat in two interviews, 'Practising Abstraction: Talking to Michael Craig-Martin' and 'A Reputation Reviewed: Talking to Andrew Graham-Dixon', both included in *Bridget Riley: Dialogues on Art*, ed. Robert Kudielka, London, Thames and Hudson, 2003, pp. 54–5 and 71–2 respectively. In 1992 she also reviewed Seurat's centennial exhibition at the Grand Palais in Paris, 'The Artist's Eye: Seurat', reprinted in *The Eye's Mind: Bridget Riley. Collected Writings 1965–1999*, ed. Robert Kudielka, London, Thames and Hudson, 1999, pp. 174–182.

2 The exhibition took place in 1997. Riley's catalogue introduction 'Mondrian Perceived' has been reprinted in *The Eye's Mind* (1999), pp. 183–191. In 1995 she contributed a paper to a symposium held during the Mondrian retrospective at the Museum of Modern Art, New York, titled 'Mondrian: the "universal" and the "particular"', *ibid.*, pp. 194–7.

3 See Riley's catalogue essay 'Making Visible' in *Paul Klee: The Nature of Creation*, London: Hayward Gallery in association with Lund Humphries, 2002, pp. 15–19.

4 W. Davies, ed. *The Poems: Gerald Manley Hopkins*, London-Vermont, Everyman, 1999.

5 See Bridget Riley, 'The Pleasures of Sight [1984]', reprinted in *The Eye's Mind* (1999), pp. 30–34.

Apricot and Pink 2001
Oil on linen
111.8 × 213.4 cm / 44 × 84 in
Private Collection
(not exhibited)

Encore
Lynne Cooke

A young artist must be aware that he does not have to invent everything anew: his job is to sort out in his mind the compatibility of the different approaches in the works of art that impress him and at the same time question nature.

<div align="right">Henri Matisse, 1945</div>

It is important to look at the best – and it is not immodest or lacking in respect to do so. The great paintings are the clearest; they have been made by those who made the greatest effort to overcome confusion and to arrive at clarity....[I]t is understanding this sorting out – and what it is that has been sorted out – that is so valuable to other painters.

<div align="right">Bridget Riley, 1990</div>

I

Pink Landscape 1960, the best known because most reproduced, of Bridget Riley's formative works, is rarely shown. Implicitly relegated to the realm of immaturity since it is based on studies made *sur le motif*, this small yet scintillating oil pays homage to a great Neo-Impressionist precursor as it expands his 'method' in new directions. Well versed in Seurat's practice from her close copy, made the previous year, of one of his smaller landscapes, *Le Pont de Courbevoie*, Riley based *Pink Landscape* on a view over an expansive plain outside Siena, a view even more austere than the vistas Seurat customarily favoured. A lowering haze, foreshadowing the approaching storm, and rendered by means of a patchwork of small strokes ranging from succulent pinkish yellow through bluish lemon, suffuses the plain. In conjunction with the high horizon, the square format creates an all-over field whose vertical axis is bisected by a faint zigzag which demarcates transitions in elevation from one hillock to the next. In this glowering light

Riley's nominal subject is virtually de-materialized. Emblematic of the way that perception itself would become her medium, *Pink Landscape* stands on the threshold of an abstract optical art.

Executed some six years later and almost double the size of *Pink Landscape*, *Static 3* 1966, is comprised of an uninflected monochrome ground laced with an irregular grid of small black ovals, variously oriented. The title was consciously chosen with reference to 'a field of static electricity'. Yet the origin of this lattice of 'visual prickles', and hence of the sensation of 'arrows...being discharged in front of your face as you look at it', lies in an experience Riley had when ascending a mountain-top covered with shale one summer, in the mid-sixties, in France. 'It was an extremely hot day', she recalled:

> I was getting anxious because we were going in a car up a steep narrow road. Visually it was total confusion; I felt there was no possibility of understanding the space of this situation. You couldn't tell whether this shimmering shale was near or far, flat or round. One of us said it was like the desert. We found it so alarming that we got out of the car, which of course intensified the sensation. But it was much cooler at the top, and into my mind came the beginnings of *Static*, a mass of tiny glittering units like a rain of arrows".[1]

When closely scrutinized, the (grid of) tiny ovals begin to sway and turn, destabilizing the ordered regularity so that space opens in a subtly elusive flow which picks up speed, then subsides and fades away, only to resume its evasive trajectory shortly after.

Few commentators have been inclined to link the dots connecting these two works, for soon after painting *Pink Landscape* Riley's style changed dramatically. She adopted a sharply contrasting black and white palette, focused on a

vocabulary of simple, repeating geometric units, and began employing assistants to execute her works to ensure an anonymous, impersonal handling. Heralded in *Movement in Squares* 1961, the painting that has most often inaugurated retrospective overviews of her work, this style was quickly identified as her signature mode. While reference to works by both Mondrian and Pollock is critical to this shift in direction, there is, however, no fundamental hiatus in her evolution: their impact on her thinking did not detach her from her roots but, rather, grounded her more fully.[2] Analysing Seurat's drawings in a review of a centennial exhibition of his work many years later, Riley offered the following incisive commentary: 'There is an almost overpowering sense of the mysterious' she asserted,

> 'Curiously enough, although its treatment may differ from subject to subject or from manifestation to manifestation, one has an unmistakable sense of the mystery being singular and constant. Superficially it can be explained to some extent by what is depicted.... But the heart of this mystery, it seems to me', 'lies more in its employment of our powers of perception. We cannot *quite* see. Within the myriad subtle distinctions of close tones, or through the magic weaving of conté marks, we cannot sometimes be sure of the identity or even of the actual forms we are looking at. To put it another way, by confronting us with an experience just beyond our visual grasp, with something unfathomable, the im-perceptible in short, Seurat asks: What is it that we are looking at?'[3].

Though the terms in which she realised *Pink Landscape* and *Static 3* are substantially different, their effects are not so far removed – and her analysis of Seurat's effect applies with equal validity to both of her own paintings. For once 'the basis of vision rather than its appearance' became her point of departure, she continued to explore perceptual sensation. Thus irrespective of how systematic any single line of enquiry might prove – as seen in the close variants that comprise the four works titled *Static* – her practice has never become programmatic or predetermined but remains, as Anton Ehrenzweig argued, always 'aware of its ultimate mystery, [of] that transformation which will give her work its independent life and secret "presence"'.[4]

II

In the early sixties Riley gained widespread recognition as a key figure in the emerging British scene. Her meteoric rise to critical and popular acclaim coincided with, as it was shaped by, a remarkable sea-change in British culture. As the post-war economic recovery generated a widespread cultural efflorescence, 'Swinging London' became the most dynamic city in the world. The explosion of artistic activity across numerous fields from music through fashion, film, photography, theatre, and the visual arts shared certain features, generating a collective image based in youth, vitality, creativity, originality, irreverence, excitement; 'clean, crisp and straightforward', 'pure, high-octane nervous energy', and 'cool' were typical epithets applied across the various spheres, from politics to culture, to capture the new ethos.[5] Among the leading artists of her generation, which included David Hockney, Peter Blake, Allen Jones, Bernard and Harold Cohen, Richard Smith and Anthony Caro, Riley stood apart on account of her formation as much as her mode of radical abstraction. Yet her decision to join the Robert Fraser Gallery in 1965 placed her firmly at the centre of that cresting wave, as did participation in certain key shows that had launched 'The New Generation', as this loose coterie came to be known.[6] Committed to the new or, better, opposed to the Establishment

in all its manifold guises, their work was enthusiastically championed for its assertive newness. In many cases, in the visual arts as elsewhere, novelty if not originality was achieved by means of rupture and rejection. Yet too often desperation usurped the role of inspiration as a radical hiatus with both the artist's formative or student years and with the art of the past became the prerequisite for the mandatory 'breakthrough' (as such reorientations were then termed). In Riley's case, however, her passage to such iconic works of the mid-sixties as *Pause 1964*, *Current 1964*, *Fall 1965*, or *Descending 1965*, evolved by way of a deep absorption in and engagement with a uniquely determined set of mentors. That is, far from becoming unmoored from the past, it was premised on the option of drawing from any and all sources within the modernist canon as they seemed relevant and appropriate: thus, for her, Seurat could be as pertinent an examplar as Pollock, or Balla as relevant as Mondrian.

When Riley's work debuted in New York in 1965, it became a *cause célèbre*, enthusiastically embraced by the popular press, and plagiarized by the fashion industry.[7] A solo show of sixteen paintings at the Richard Feigen Gallery was timed to coincide with 'The Responsive Eye', a high-profile exhibition curated by William Seitz for the Museum of Modern Art, which featured two of her most recent paintings. Taking their cues from the strong representation of Albers and Vasarely, who were the senior artists highlighted in the exhibition, the inner circles of the New York art world perceived this heterogeneous show as a promotion of a *retardataire* European-based art, an art whose roots lay in early twentieth-century abstraction. Typical in his response was painter and *Artforum* denizen Sidney Tillim, who traced a lineage from the Bauhaus through Constructivism to the generation of mostly younger European avatars of the latest manifestation, dubbed Op-art, among whom he included

Riley.[8] For his colleague Barbara Rose, a more impassioned proponent of so-called advanced art, only the works of a few Americans, namely Ellsworth Kelly, Morris Louis, Kenneth Noland, Larry Poons and Frank Stella, warranted attention, even though she found their inclusion anomalous, ancillary to Seitz's governing premises. Albeit from a more rigorously articulated position, her fellow contributor Rosalind Krauss reached almost identical conclusions.[9] Based in high-key colour, a holistic composition, a disembodied optical space, and a de-personalized handling, the work of this loose-knit cluster of New York artists was vigorously championed by Michael Fried, Rose and others identified with *Artforum*, a highly influential if internally fractious cabal at the very centre of the centre. Ironically, their contestatory theoretical rhetoric rendered them impervious to almost all work created outside their immediate backyard.[10]

. . .

The inclusion of numerous drawings and working studies in Riley's second Feigen show the following year revealed the painstakingly wrought basis of her practice, and its foundations in traditional methods and preparatory techniques. Whether consciously or not, their presence countered the false accusations levelled the year before that she adopted or borrowed wholesale scientific diagrams, optical experiments and the like. In her perceptive review of these works, Rosalind Krauss incisively analysed a final study for *Arrest 1965*. Yet she concluded by categorizing Riley's whole endeavour as 'timidly pleasant', as mired in safe taste, a judgement wildly at variance with the responses accorded Riley's art in her homeland from both the professional and the popular sectors of the art world.[12] Whereas to her London-based apologists her work bore the strong imprint of post-war American art in its ambition, radical abstraction, flatness and

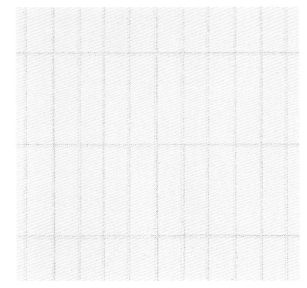

all-over composition, their Yankee counterparts generally dismissed it as outside the bounds of the permissible, the (narrowly) viable.

In 1968, in her third exhibition with Feigen, Riley presented four paintings plus sundry drawings and prints. This particular selection included one older work, alongside three new ones, all on a more monumental scale than those she had previously shown in Manhattan: two paintings from the *Static* series, 1966, *Exposure* 1966, and *Ascending and Descending Hero* 1963, remade in 1965. The bold but relatively straightforward compositions of these latter two paintings contrast with the expansive but elusive, subdued and subtle compositions of *Static* 1 and 2. Compared, however, with the powerful, pulsating vortices that characterize the modestly sized works of 1963–4, the four canvases taken together signal a growing tendency to a fugitive, rippling shallow optical space, proximate to the picture surface. Destabilized in ways that almost elude perception, that verge on the imperceptible, they (together with two works titled *Deny*, which immediately followed) mark the culmination of a highly fertile period in Riley's career. In addition, they reveal telling correspondences with certain works painted in the US at that moment: a related concern with issues of perception – with seeing as an embodied act in time, that is, involving time – informs the current work of Ad Reinhardt, Agnes Martin and Robert Irwin (all of whom were included in 'The Responsive Eye'). Their works too employ a process of de-differentiation in a highly conscious way as part of the act of looking. Recourse to de-differentiation – to a broad unfocused scanning as a component within the act of perceiving – in order to construct a holistic, all-over field contrasts fundamentally with the compositional strategy generally preferred by Louis, Noland and their cohorts; the use of a *gestalt* which coheres almost instantaneously.

The reasons that affinities between Riley's, Martin's, Irwin's and Reinhardt's work escaped contemporary notice may lie as much in the presumption that all these artists occupied positions on the periphery of the dominant discourse on painting at that moment – that is, on sectarianism – as in the insularity of local critics' perspectives.[11] At the heart of this indifference lay Riley's contravention of certain key tenets – notably the privileging of a disembodied viewer, the commitment to high-key colour as the principal means to structure and construct a shallow optical space, and an ineffable content apprehended as 'a state of grace' – that characterized the abstract painting then heavily promoted in New York. Riley, as Thomas Crow perceived with the benefit of hindsight, 'had the temerity to exercise a certain control over the viewer's mental state, to trigger palpable physical experiences of heightened mental alertness: she meant the viewer's involuntary cognitive responses to recall sensations, in her words, of "running...early morning...cold water...fresh things, slightly astringent". For taking that reasonable measure of the powers of abstract painting, as well as for recognizing the inherently physical, bodily character of optical perception,' he concluded, 'the[se] Modernists could never forgive her'.[13]

III

In a conversation published in 1965, British critics Andrew Forge and David Sylvester, recently returned from visits to the reigning art capital, sought to characterize the salient differences between the Manhattan and London scenes. 'The over-riding impression' Forge had gained from his trip, 'was of the enormous variety and also the enormous compactness of the American [actually, New York] situation – the feeling one has that everybody knows about everybody else's painting and

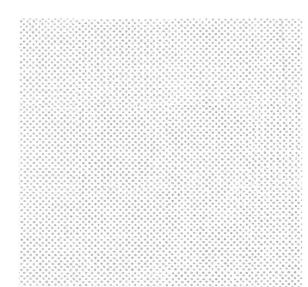

far left:
Robert Irwin
Untitled
1966
Oil on canvas

left:
detail

that there is a kind of running commentary going on within each work".[14]

'This creates a very concentrated and electric ambience: the least inflection that an individual artist puts into it counts and has repercussions and echoes, which other people can pick up and use. There is a kind of critical activity which is going on hand in hand with the creative activity, a kind of questioning, a kind of standing aside from the involvement of art in order to criticize, to take up fresh attitudes and then to find a way of incorporating them in the work itself. So far from being an inhibition, as one can be sure many painters here would regard it, the criticism actually becomes creative material to be built in to the production of the artist'.[15]

This seemed to him radically different from the situation facing the stereotypical English artist: 'a solitary man of conscience working simply with what God gave him in his studio'. Agreeing that British artists' work usually evolved as a response to internal arguments in the absence of important external ones, Sylvester speculated that the malady was endemic to a provincial situation. In support of this claim he invoked an observation offered by Max Kozloff, an American contributor to *Artforum* who was also familiar with the contemporary British context, that the centre was never outward — but always inward-looking, that 'an inspired hermeticism...is a contingency of advanced art'.[16]

Optimistically, all three commentators anticipated a significant change in the British situation. For, unlike their predecessors, Patrick Heron, William Scott, Francis Bacon et al, (who had initially looked to Paris), the newly emerging sixties generation had encountered the ground-breaking work of the Abstract Expressionists at a formative moment: consequently they were 'able to assess its quality not as a novelty, but simply as part of their experience of learning what painting consisted of': unlike the previous generation, they had 'a much more integrated attitude towards the great stylistic changes that American painting brought about'.[17] Yet, in contrast to their American counterparts, for whom those titanic father figures were still unavoidably present, these young British artists had a broader pool to draw from: they needed to consider not only the immediate past; they could adopt a longer, historical perspective. Thus the trio of critics concluded that this promising context would produce artists who were acquisitive and canny, learned yet open, where their predecessors had too often been restrained, amateurish, fastidious, timorous, and well-bred — in short, bland.

Like many of this generation, Riley had attended the Royal College of Art in the early 1950s though, compared with the rigorous training in draughtsmanship she had received as an undergraduate at Goldsmith's College, she found the experience disappointing.[18] In the late fifties she too responded strongly to the onslaught of Abstract Expressionist painting, and in particular to the work of Jackson Pollock then being shown for the first time in Britain.[19] Her US debut also coincided with that of others of her immediate circle. Following the equivocal (mis)reading of her work in the mid-sixties, however, she adopted a path that distanced her further from contemporary American developments whereas they generally did not. At the same time, the London art world in the later sixties failed to realize the creative potential that Sylvester, Forge and Kozloff had envisaged: in place of the vital, generative, critical environment they anticipated, it remained eclectic, conciliatory and dispersed: a provincial New York outpost.

Largely self-fashioned, Riley's hard-won aesthetic not only increasingly divorced her from the American vanguard establishment, it also isolated her in London. Her abiding conviction, stemming back to her early training, of the necessity

of always focusing on 'the best' meant that she remained as engaged with the great pioneers of Modernism as with any of its subsequent avatars.[20] Estranging her inevitably from her immediate fellows and from topical and local issues, this belief also alienated her from the whole Greenbergian derived mind-set concentrated on so-called 'advanced art'. In pursuit of what she called 'the real problems of paintings' embodied in a long and continuous pictorial tradition stemming from the Renaissance, she did not, however, repudiate her self-consciously Modernist position.[21] That this relative and largely self-imposed isolation has not mired her in her studio, working simply with what God gave her, to adopt Forge's formulation, is evident from the enthusiasm with which she travels to see exhibitions of her mentors, and the closeness with which she has scrutinized the art of, first, Jasper Johns, and more recently, Bruce Nauman and Richard Serra among her contemporaries.[22]

IV

In 1960, Riley felt the necessity of renouncing colour in favour of black and white as she tried to absorb the lessons of the new American art, and of Pollock's work in particular. Colour seemed inherently wayward, impossible to discipline, and hence, like the trace of the author's hand, an impediment to clarity and simplification, to the principal means for conveying visual sensations. She did not, however, give up on colour altogether but in the following years made a number of attempts – albeit futile – to incorporate it into her practice. Unable to create colour-form as distinct from what she regarded as merely coloured forms[23], she only gradually integrated it in the later sixties through the vehicle of tonal greys, that is, of greys ranging from the warmer and cooler ends of the spectrum as found in *Deny* I and II, 1967. Beginning with *Late Morning* 1967–8, and culminating in *Pæan* 1973, she

finally resolved the problem by restricting her palette mostly to intense, highly saturated reds, blues and greens. Weaving this triad together in narrow bands, interspersed with white, created a vivid light, a flickering surface play equivalent to what she had formerly achieved in her signature black and white works, such as *Blaze* 1 1962. As Riley confronted the problem of creating an optical space with high-keyed colour she had recourse once again to Seurat, a choice that further removed her from her American peers for whom the art of Matisse was the prerequisite point of departure for any engagement with colour. Luminous breathing colour – the sensation of light suffused from within – that was a hallmark of Matisse's work for artists in the sixties depended on the sensitivity of his touch, on his nuanced handling. These were means that Riley had long renounced. If Matisse therefore seemed to offer her few options at that time, this impression may have been enhanced by the almost dogmatic fervour with which his art was then embraced by American painters.[24] Several factors therefore must have predisposed Riley to revisit her former mentor whom she considers an abstractionist *avant la lettre*: working with pure colour in carefully controlled and studied relations Seurat had created an extraordinary range of luminous effects. Moreover, while he explored a scientific basis in his study of chromatic relations, this was never at the expense of an intuitive study of its emotional and expressive qualities. In this, he also drew on lore long known to the greatest colourists from Titian and Veronese through to Delacroix. While curious about the quasi-scientific analyses pursued by Seurat and others in the late nineteenth century, Riley, too, quickly recognized that colour ultimately has no systematic, knowable foundation but can only be handled by means of experience, intensive analysis and patient research.[25] By deliberately constraining and scrupulously controlling her chromatic options, restricting her composition to slender

vertical stripes and adopting a larger format, Riley created in *Pæan* (and its siblings) a painting that initially was encountered as a single holistic entity: a horizontal movement of light in counterpoint to a vertical field of brilliant stripes in pure hues. Since its parts would only reveal themselves on extended viewing, the pleasures of sight could be exercised in the extraordinarily fresh, luminous diffusion parsed across a monumental surface that was as grand as any in post-war painting. Nonetheless, a straight line can still be drawn connecting *Pink Landscape, Static 2* and *Pæan*, a line whose fundament is the work of Seurat.

During the mid-seventies, as witnessed by *Song of Orpheus*, 1975 and *Andante* 1978, Riley interwove into complex skeins serpentine ribbons drawn from a nuanced palette ranging from pinks and yellows to lavenders. Colour-form, as she had now come to understand it, had dual roots in Modernism: one strand, originating in Impressionism and Monet above all, then developed by Seurat, created an optical space from scintillating hues; the second, stemming from Cézanne, produced a more plastic space. To this latter she turned in the early eighties in what was to become known as her Egyptian series.

As colour continued to occupy the forefront of her formal concerns, drawing, her first love, was relegated to a subordinate position. In pursuit of the maximum chromatic luminosity, Riley had turned to stripes, which, having very little body (in that they are mostly 'edges')[26], intensify the interaction between colours that share their extended borders. Only in the later eighties, when she began producing the series of Lozenge paintings, also known in studio parlance as 'zigs', did drawing take on a more active role. In the guise of a tightly knit armature, it permitted the introduction of an unprecedented range of hues, structured and combined in highly complex ways which draw the eye around and through the picture space. Composed from up to twenty different hues

these works bear affinities structurally to Divisionism (and Futurism) filtered through Mondrian. Her quest for an intense chromatic interplay that draws the eye around, across, back and forth along multiple divergent axes in a dynamic vivacious sparkle, was not, however, resolved by a study of Neo-Impressionism any more than it resided fully in probing Cézanne's methods. As intimated in Dave Hickey's moniker for these works, 'Bridget's Veroneses', its roots lie much deeper in traditions that form the core of Western painting.[27] Fostered by her seven-year stint as a trustee at the National Gallery in London from 1981 through 1988, Riley examined these traditions closely. In 1989 when planning her contribution to the 'Artist's Eye' series (in which an artist, serving as curator, chose works from the National Gallery's collection), she initially proposed to focus her exhibition on the theme of perception in relation to nature: this would have involved a selection of mostly landscape paintings by Cézanne, Monet, Seurat and their peers. Ultimately, she opted to examine the colourists' lineage in figure painting: her final constellation stretched from Titian, through Veronese, El Greco, Rubens and Poussin, and ended with Cézanne, represented by an image of bathers conjured in his imagination rather than by studies made after nature, *sur le motif*.[28]

In pursuing this line in her own work as well as in her exhibition, Riley did not in fact depart from the model offered by Cézanne and his generation of Modernists, who argued that their home was in the museums as much as in nature. Yet in her persistently 'long' vision across the spectrum of Modernist endeavour and into the deeper reaches of the past, she again parts company with her American peers, Johns, Marden, Martin and Ryman, among others, who appear to have a shorter memory span in that they are inescapably burdened with the challenge of digesting the ever-present legacy of Pollock, Newman and their associates. Even those American

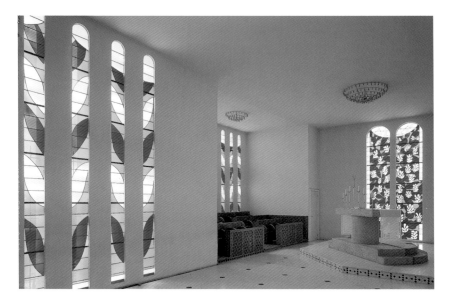

Henri Matisse
Interior view of
the Chapel of the
Rosary, Vence,
France.
Constructed 1951

painters, ranging from Milton Avery through Ellsworth Kelly, who sought salvation directly from Matisse, found few avenues which permitted them to shake off the constraining commitment to a declaratively 'advanced' form of art.[29]

V

Since her course had been determined primarily by internal imperatives, reinforced by a particular set of circumstances (and possibly also by an instinctive recoiling from the long shadow cast by Matisse on those of her New York-based peers who counted themselves his heirs), Riley entered her fourth decade, in 1990, as a painter having never addressed in any significant way the legacy of the twentieth-century's greatest colourist. By the end of that decade she found to her surprise that while she had not deliberately sought him out, she had 'arrived at Matisse.'[30] This belated and most singular of Riley's dialogues with one of the founding figures of Modernism is still in a highly active state, so it is too early to draw clear conclusions from the encounter. But on the evidence to date, it may prove to have generated one of the most thoroughgoing transformations in her oeuvre.

As would have been evident to Riley, who is her own best critic, as to anyone else closely following her evolution over the past four decades, her characteristic tendency is always to move forward by looking back. Given an overriding commitment to clarity and simplicity, which she shares with Matisse, whenever her work appears to be threatened by refinement, by an intricate complexity, she has pulled up short, and sought a new direction: 'As Matisse knew', she commented in 1990, 'to preserve a freshness in working one sometimes has to go back to first principles'.[31] Thus, for example, in the late seventies the *Song of Orpheus* paintings were followed by the grander and graver Egyptian series. By the mid-nineties she had reached a

related impasse with the lozenge paintings. Resolution came unexpectedly through a commission for a large wall drawing for a group show in Berne in 1998. Wrestling with lessons learnt there she eventually introduced series of interlocking arabesques into the zigs. Coupled with a radical pruning of her palette in the interest of clarity and simplicity, these rhythmic arabesques brought her (back) to Matisse. Completed in that same year, 1998, *Rêve* is the first painting in this, her latest body of work. Evoking the dreamlike arcadian world beloved of Matisse, its apt title also recalls, perhaps fortuitously, the villa in Vence, 'La Rêve', where Matisse spent the years 1941–1948, the years in which his last great phase, the *papiers découpés*, emerged along with that remarkable *gesamtkunstwerk*, the Chapel of the Rosary.[32]

The ground for this encounter had been well prepared: Riley was no stranger to Matisse's art. In 1959–60 she visited the Chapel in Vence for the first of many times. Today she still vividly recalls the impact that the row of narrow windows with their symmetrically composed leaves in blue, yellow and green made on her. As they cast pools of brilliant colour on the white floor they simultaneously created an ambience of magenta light – an effect that the delighted Matisse also had not anticipated. In 1977 she made a special trip to Detroit to see the landmark exhibition of *papiers découpés* presented at the Detroit Institute for the Arts. And in the winter of 1993–4 she travelled to Paris to see the newly (re-)discovered third of the three cartoons Matisse executed for the Barnes Mural, when it was shown together with the other two versions. Earlier that year she had spent an extended period in New York in order to study closely the Matisse retrospective at the Museum of Modern Art. Most recently, in 2000, enthralled by the prospect of comparing the twin colossi of the twentieth century, she saw the Matisse/Picasso exhibition in two of its three incarnations: in London and New York. Contrary to current wisdom, she

Henri Matisse
La Danse 2
1909–10
Oil on canvas
The State Hermitage
Museum,
St Petersburg

concluded that Picasso was the artist with more charm, that Matisse was the 'tougher' of the two.[33]

While Riley had obviously encountered a vast number of Matisse's works elsewhere, on other occasions, it is telling that this singular history of concentrated interactions begins with his late works, with the Vence Chapel and the great decorative schemes. In such works as *La Piscine* 1952, *L'Escargot* 1953 and *Mimosa* 1949–51, with their layered fields of limpid warm and cool hues, Matisse carved directly into pure unmodulated colour in order to synthesize line and colour, and to find a new potential for structural decoration. To date Riley has commented only briefly on Matisse's work, in a short text devoted to *La Danse 2* 1909–10, now, with its companion, *La Musique* 1910, in the Hermitage in St Petersburg. In the rare level of abstraction – thematic as much as formal – that is a hallmark of this pair of exceptional works, lie the seeds of his final phase. While drawn to their brilliant effects of luminous colour, Riley emphasizes the crucial role played by the rhythmic linear armature in conjuring the subject:

> '[H]e settles the colour on a bold contrast and harmony principle...and concentrates his efforts on pulling out the huge curves and diagonals which play with and against each other around the canvas. Arms and legs, whole bodies even, are lengthened and shortened as the development of the rhythm demands.... The group, subject to the overall organization of colour and rhythm and entranced by the act of dancing, lose their separate identities and become one pictorial form, one organic unit.... In literal terms the subject may be one man and four women dancing, but the content as it emerges is the plastic expression of the spirit of the dance, movement represented as a visual rhythm in which interchange acts as a constant.'[34]

It is this aspect, above all, that links these works most closely to two of the most ambitious works in the recent series: *Parade* 1999, and *Evoe* 2002. Imbued with intimations of a resonant figural scale, they evoked 'bacchanals without the revelers'.[35] Yet it is elsewhere, in works such as *June 12 Bassacs* 1998, and *Apricot and Pink* 2001, that something even more unexpected begins to emerge: a way of synthesizing drawing with colour to more decorative, expressive ends. For they foretell a novel way of structuring in which radiant irregular shapes, unmoored from the taut rectilinear scaffolding still implicitly undergirding the field, appear almost to float. Gently tethered by their contours to elements in a second dominant hue, these liberated shapes of limpid colour generate an ebullient radiant energy and sensuous immediacy. In subsequent works such as *Two Reds* 2000, and *Enchant* 2004, no single colour-form reads as figure to another seen as ground, that is, none becomes fixed as a positive in relation to its neighbour read as negative. Rather, they fluctuate in a reciprocal movement that keeps both active at once, a contrapuntal movement that recalls the equivalency binding black and white in many early works, such as *Descending* 1965. More pertinently, it also recalls certain ways of drawing a motif that Matisse developed in later life. Maurice Merleau-Ponty, whose writing on the embodied viewer was a seminal influence on Riley's thinking from her earliest days, eloquently conjures this effect: 'It is Matisse who taught us to see their contours not in a "physical-optical way" but rather as structural filaments, as the axes of a corporeal system of activity and passivity'.[36]

Nonetheless, the biggest shifts to date – an engagement with a Matissean sense of the decorative – originate in some of Riley's more modestly scaled works on paper. In several of her most adventurous recent studies with a more vertical orientation, such as *July 9, Bassacs* 1998, or *November 1, Magenta and Green* 1998, singular, almost idiosyncratic shapes – flame-

Henri Matisse
Mimosa
1949–51
Museum of
Twentieth
Century Art,
Itoh City, Japan

Henri Matisse
Ceramic tiles
for *Apollon*,
photographed
in the Charles
Cox studios,
Juan-les-Pins,
France, c. 1953

like forms in two contrasting hues of equal value – flicker over the surface in dynamic play, a flux of rivalrous solicitations. Despite the restriction to two or three basic colours, their expansive mood opens new options, reminiscent of the decorative as Matisse employed this multivalent concept.[37] Over the course of his life, albeit with shifting inflections, he employed it to encompass a nexus of interrelated notions: the investing of pattern with spatial properties, a fealty to the totality of the painted surface, and later, an all-over chromatic field that radiated light. In their repetition of related but slightly different elements, and their playful effervescent delight in reversals and ambiguities, these works bear affinities in their disjunctive patterned interlaying of close valued colour with, say, *Mimosa*, while in their corporeal interchange they echo the reversals in *La Piscine* where some of the swimmers' bodies are rendered in white, and others in blue. As seen in *Painting with Two Verticals* 2004, Riley is just starting to venture into this arena with large-scale oils. A monumental tripartite composition, *Painting with Two Verticals* imbricates shape with armature so that the blue forms are momentarily identified as ground, then chameleon-like, and almost simultaneously, they assume the guise of an active integer, a figure – or vice versa. In this finely calibrated flux, a fugitive stability, anchoring and ordering, temporarily supervenes within a larger dialectic, a lateral weighing and balancing poised on the central section, a 'panel' whose borders are determined by the eponymous two verticals. Earlier this year, Riley made a trip to the Alhambra, the acme of Islamic ornamental sophistication. It is surely not irrelevant that Islamic art was for Matisse a life-long and primary source of inspiration, above all for its colouristic richness and strong decorative appeal.[38] Taken in conjunction with certain of her subsequent works notably *Painting with Two Verticals*, this visit attests to a deepening fascination with questions of how

colour-form not only creates space but how painting and decoration may interact in architectonic terms.

VI

In an illuminating recent study, Richard Shiff links Riley to Matisse through what he sees as a shared preoccupation with paradise, with an arcadian world enclosed and set apart temporally as well as spatially.[39] For both artists, he argues, this Edenic milieu is conjured through sensation, that is, it is generated by the very means of painting itself as much as by any particular subject or thematic. While throwing much new light on Riley's vision and conception of what a painting could and should be, his essay does not situate Matisse relative to the other key figures within Riley's pantheon: Seurat, Cézanne, Klee, Mondrian and Pollock. Nor, given the fundamental accord he believes has aligned their visions from her earliest days, does he indicate why Riley might formally have arrived at Matisse's art so late in her career. It may not be irrelevant to her formation that Seurat and Cézanne, who first occupied her so deeply, should be well represented in public collections in London whereas Matisse is not. Prior to any sustained engagement with art were the transforming experiences she had as a child in Cornwall during the Second World War, where, stimulated by the natural world around her, she developed an avid and acute taste for visual perceptions. She honed an acute responsiveness to natural phenomena and sensory impressions. Thus she did not come to art through art: only through pleasure in perception was she eventually drawn to Impressionism, and from there to the idea of becoming an artist herself. Given this background, Riley was almost inevitably predisposed towards the art of Seurat and Cézanne, a bias that the cultural context itself reinforced.

Although Riley has returned periodically to Cornwall

where she has a studio, this is not her sole escape from her London home and the daily business of her practice, which involves working with various assistants. If she continues to find in Cornwall a rich vein of nourishment, at least as important to her in recent years is the residence she acquired in the south of France in the early sixties. In 1962 Riley purchased a property in Vaucluse where she could live and, later, work in seclusion. Although it was not until the seventies that she actually set up a studio there where she can work undisturbed for long stretches of time, her allegiance to this Mediterranean milieu is deep and profound. Long an unparalleled fount of European culture, its memorable terrain is thoroughly imbued with the spirit of not only Cézanne but Matisse (and Van Gogh – but that is another story). Although to her an adopted world, this seedbed of Modernist painting has become the repository for her deepest cultural roots. Occupying a seminal role in her imaginary, it is symptomatic of the profound difference that still separates her from American peers for whom (Twombly apart) Europe is ultimately the Old (World) rather than a site of continuous cultural renewal. In Matisse's case the past remained an active force in his experience rather than an attenuating one, Pierre Schneider argues in his great monographic study, a book Riley admires.40 One of the key insights informing Schneider's analysis, this notion can be applied with equal validity to Riley's practice: for her too, the past is vigorously alive, an ever-present point of departure.

Footnotes

I am grateful to Simon Baier for assistance with research for this essay.

1 Bridget Riley, Interview with David Sylvester, 1967, reprinted in *The Eye's Mind: Bridget Riley Collected Writings 1965–1999*, ed. Robert Kudielka, Thames and Hudson, London, 1999, p. 76.

2 For a close account of the impact of these two artists on her work and thought, see the essays by John Elderfield, 'The Change of Aspect', and Lynne Cooke, 'Around and About *Composition with Circles 2*', in *Bridget Riley: Reconnaissance*, Dia Center for the Arts, New York, 2001. Riley has referred repeatedly to this connection, i.e. in conversation with Maurice de Sausmarez 1967, 'According to sensation' in conversation with Robert Kudielka 1990 and 'Mondrian: the 'Universal' and the 'particular'', 1995, all of these were reproduced in *The Eye's Mind*. In several other paintings from 1961 containing what she refers to as 'buried forms', such as *Tremor*, or *Hidden Squares*, where images are imbedded in a larger field. Critical to the maturation of Riley's work in 1960–61 was her close association with Harry Thubron, Maurice de Sausmarez and others who were then devising a foundation course based in a Bauhaus return to first principals, and in the practice of Paul Klee, as set forth in his seminal texts, 'The Thinking Eye' and 'Pedagogical Sketchbook'. Solidly grounded in the rudiments of drawing from her earliest days as a student at Goldsmith's, 1949–52, Riley seems to have imbibed from that much valued training a conviction that she should know her means, as both a craft and a tradition to be embraced. Tradition in this sense was understood not as a predetermined or fixed canon but something to be constructed by each individual artist as needed from a study of the best. At this time she also became convinced, via the writings of Stravinsky, that constraint and self-imposed limits were an essential part of the learning process.

3 Bridget Riley, 'The Artist's Eye: Seurat', 1992, reprinted in *The Eye's Mind*, op. cit., p. 175.

4 Anton Ehrenzweig, 'The Pictorial Space of Bridget Riley', *Art International*, February 1965, p. 21.

5 For a study of these sweeping historical, social and cultural changes see Christopher Booker, *The Neophiliacs*, Gambit, Boston, 1970, especially chapters I and II, 'Portrait of an Image', 'Awakening toward a Dream'.

6 The principal show defining this group was 'The New Generation', held at the Whitechapel Art Gallery, London, in 1964, under the directorship of Bryan Robertson. Note also 'Painting and Sculpture of a Decade, 1954–64', Tate Gallery, London 1964; and 'Contemporary British Painting and Sculpture', Albright-Knox Art Gallery, Buffalo, 1964–65, which then toured through the United States.

7 For a fuller analysis see Lisa G. Corrin, 'Continuum: Bridget Riley's 60s and 70s: A View from the 90s', *Bridget Riley: Paintings from the 1960s and 70s*, Serpentine Gallery, London, 1999, pp. 35–43.

8 Though a frequent contributor to *Artforum*, Tillim published this review in *Arts Magazine*, a more eclectic forum: 'Optical Art: Pending or Ending?' *Arts Magazine*, January 1965, pp. 16–23. It was not only American commentators who made this link. See, for example, Norbert Lynton, 'Optical Art', *New Statesman*, Weekend Edition, 29 May 1964, pp. 853–854.

9 Barbara Rose, 'Beyond Vertigo: Optical Art at the Modern', *Artforum*, April 1965, pp. 30–33. Rosalind Krauss's review of the exhibition was in fact published in *Art International*. ('Afterthoughts on "Op"', *Art International*, June 1965, pp. 75–76). Very different in tone, spirit and evaluation were the encomia, more journalistic than academic, published in *The*

New York Times by John Canaday: 'The Responsive Eye. Three Cheers and High Hopes', The New York Times, 28 February 1965; 'That's Right It's Wrong', The New York Times, Sunday 14 March 1965.

10 The exception was British sculptor Anthony Caro whose work was championed by Michael Fried and others in the early sixties. While he, together with several British sculptors such as Philip King, was featured in the landmark 'Primary Structures' exhibition held at the Jewish Museum in New York in 1966, he was soon eclipsed by the rising Minimalists, who quickly dominated critical discourse.

11 A study of the relations between these and other abstract painters then closely engaged with issues of perception, and the fertile conceptual ground on which this was premised remains to be undertaken. Relevant to all these artists' work is The Hidden Order of Art (published posthumously in 1967), and other writings by Anton Ehrenzweig, Riley's friend and early supporter.

12 Rosalind Krauss, 'Bridget Riley', Artforum, June 1966, p. 50. See also Kermit Champa, 'Recent British Painting at the Tate', Artforum, March 1968,pp. 33–37, for a similar assessment.

13 Thomas Crow, The Rise of the Sixties: American and European Art in the Era of Dissent, Abrams, New York, 1996, p. 113. A British art historian now living and working in the United States, Crow's study of the decade offers a fresh, independent account, at odds with more canonical texts written from a New York perspective.

14 'A Kind of Anarchy: A Conversation between Andrew Forge and David Sylvester', Encounter, vol. 23, 1964, pp. 44–48. Forge and Sylvester were, arguably, the most incisive and best-informed British critics of the day.

15 Ibid.

16 Ibid.

17 Max Kozloff, 'British Painting Today', Encounter, January 1964, pp. 39–42.

18 'Student at the Royal College of Art' (1988), reprinted in The Eye's Mind, op. cit. p. 35.

19 Two shows in particular were critical in bringing Pollock's work to her attention 'Modern Art in the United States', Tate Gallery, London, 1956, followed by a retrospective of his painting at the Whitechapel Gallery, London, in 1958.

20 See 'Bridget Riley: Personal Interview', by Nikki Henriques, 1988, reprinted in The Eye's Mind, op. cit., p. 28.

21 Quoted in 'According to Sensation: In Conversation with Robert Kudielka', reprinted in The Eye's Mind, op. cit., p. 116.

22 See, for example, her essay, 'Nauman's Formalism', 1999, reprinted in The Eye's Mind, op. cit., pp. 212–216.

23 Bridget Riley in conversation with Robert Kudielka in The Eye'e Mind, op. cit., p. 82.

24 See, for example, Clement Greenberg, 'Influence of Matisse', Acquavella Galleries, New York, 1973, n.p.; Stephanie Barron, 'Matisse and Contemporary Art', Arts Magazine, May 1975, pp. 67–68; Gunda Luyken, "Painting alone remains full of adventure": Matisse's Cut-Outs as an inspiration for Nicholas de Stael, Ellsworth Kelly and Andy Warhol' in Henri Matisse: Drawing with Scissors. Masterpieces from the Late Years, Prestel, New York, 2002, pp. 151–159; for a more in-depth study see John O'Brian, Ruthless Hedonism: The American Reception of Matisse, University of Chicago Press, Chicago and London, 1999.

25 'Perception and the use of colour', in The Eye's Mind, op. cit., pp. 33–49.

26 'Into Colour', in The Eye's Mind, op. cit., p. 92.

27 Dave Hickey, 'Bridget Riley for Americans', in Bridget Riley: Paintings 1982–2000 and Early Works on Paper, PaceWildenstein Gallery, New York, 2000, p. 7.

28 'The Artist's Eye: Bridget Riley', National Gallery, London, 1989. See also 'The Art of the Past: Interview with Neil MacGregor', in Bridget Riley: Dialogues on Art, Zwemmer, London, 1995, pp. 16–32.

29 Conversely, through the Museum of Modern Art, New York, and Alfred Barr, American artists had unrivalled access to Matisse's art in the 50s, 60s and 70s. In conjunction with a retrospective in 1951 Barr published a book, Matisse, His Art and His Public, that is among the finest monographs on any twentieth-century artist; and the holdings of Matisse's work in MoMA's collection are also exceptionally rich.

30 Quoted in Lynn MacRitchie, 'The Intelligence of the Eye', in Bridget Riley: New Work, Kaiser Wilhelm Museum, Krefeld, 2002, p. 19.

31 Bridget Riley, 'According to Sensation: Bridget Riley in Conversation with Robert Kudielka,' in Bridget Riley, Sidney Janis Gallery, New York, 1990, n. p.

32 Numerous other parallels can be drawn, such as the fact that each has a black and white drawing style quite different from their concurrent work in colour; compare Vence Chapel, with Riley's wall drawings and oils.

33 Personal communication with the author, 6 September 2004.

34 Bridget Riley, 'Henri Matisse: The Dance', unpublished text, September 1990 an abbreviated version of this text was published in The Telegraph Magazine, 27 October 1990. Yet her interest in composing for such a frieze-like format goes back some years, see, for instance, her comments to Neil McGregor on Mantegna's frieze, The Introduction of the Cult of Cybele at Rome, 1504–5, in the collection of the National Gallery (interview with Neil McGregor, op. cit., p. 23).

35 Bacchanal without Nymphs was a first proposal for Evoe, and Bacchanal without Satyrs for another untitled painting. (Quoted in Robert Kudielka, 'Abstract Figuration: On Bridget Riley's Recent Curve Paintings', in Bridget Riley, Tate Gallery, London, 2003, p. 155).

36 Maurice Merleau-Ponty, 'Eye and Mind', in The Primacy of Perception and Other Essays on Phenomenological Psychology, the Philosophy of the Arts. History, and Politics, ed. James M. Edie, Evanston, Ill., Northwestern University Press, 1964, p. 184.

37 Some measure of the distance her thinking has moved in recent years may be gauged by comparison with these comments from an interview in 1978: 'Form and colour seem to be fundamentally incompatible – they destroy each other', Riley argued. 'In my earlier work when I was developing complex forms, the energies of the medium could only be fully realized by simplifying colour to a black-and-white constant (with occasional grey sequences). Conversely, colour energies need a virtually neutral vehicle if they are to develop uninhibitedly. The repeated stripe seems to meet these conditions'. (Quoted in Lynne Cooke, Bridget Riley: Reconnaissance, Dia Center for the Arts, New York, 1999, n.p.) For Matisse's relation to Islamic art, see John Golding, 'Introduction', Matisse Picasso, Tate, 2002, pp. 15–16.

38 For Riley, travelling, even for pleasure, is ultimately connected to her practice: 'The sort of holidays I take are part and parcel of my work as a painter' she stated in an interview in 1996. ('Holidays: talking to Vanya Kewley', Collected Writings, op. cit, p. 44).

39 Richard Shiff, 'Rasters in Paradise', in Bridget Riley: Recent Paintings, PaceWildenstein, New York, 2004, pp. 5–19.

40 Pierre Schneider, Henri Matisse, Rizzoli, New York, 1984 (new edition, 2002).

West London studio, cartoon with collage, c. 1984

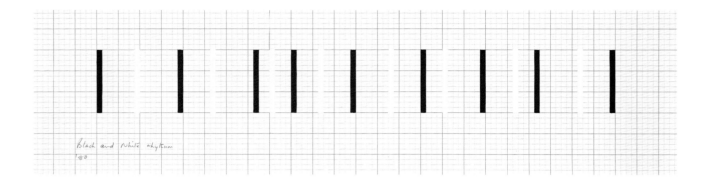

82
Black and White Rhythm 1980
Gouache on graph paper
27.3 × 58.4 cm / 10¾ × 23 in
Collection of the artist

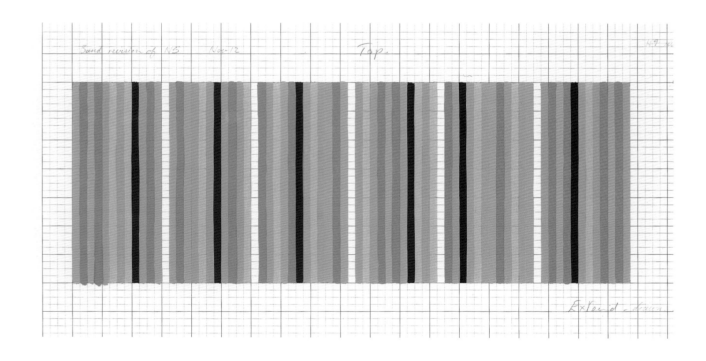

83
Green, Red, Blue and Yellow. Revision of N5 1980
Gouache on graph paper
28 × 55 cm / 10⅞ × 21½ in
Collection of the artist

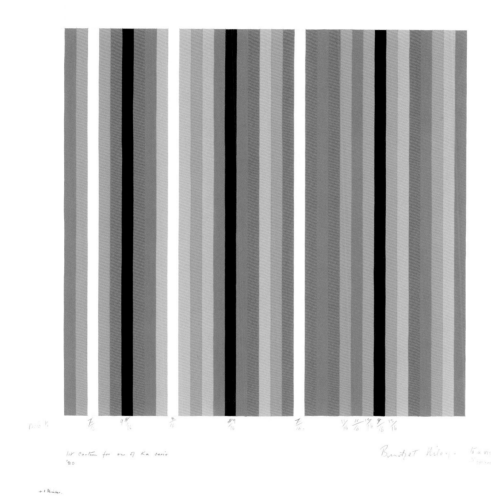

81

1st Cartoon for one of *Ka* Series 1980

Gouache on paper

75.6 × 68 cm / 29¾ × 26¾ in

Collection of the artist

85
Rough Study 2 towards *Silvered* 1981
Gouache on graph paper
95.1 × 71 cm / 37 × 27⅝ in
Collection of the artist

Rough Stripe Study with Blue, Turquoise, Yellow and Green 1983
Gouache on graph paper with collage
96.5 × 78 cm / 38 × 30¾ in
Collection of the artist

26

Silvered 1981

Oil on linen

240.7 × 203.2 cm / 94¾ × 80 in

Private Collection

27
Big Blue 1981–2
Oil over synthetic polymer paint on linen
234.5 × 201 cm / 93¾ × 79¼ in
Queensland Art Gallery
Purchased 1984

28
Bali 1983
Oil on linen
237 × 195.1 cm / 93¼ × 76¾ in
Private Collection

29
Tabriz 1984
Oil on canvas
217.2 × 181 cm / 85½ × 71¼ in
Private Collection

Study b: 15/10/85.

Bridget Riley '85

87
Study B: 15/10/85 1985
Gouache on paper
62.5 × 55.2 cm / 24⅜ × 21½ in
Collection of the artist

88

Further Revision of June 29th A (Rough Study for _Ease_) 1986
Gouache and pencil on paper
72.5 × 68.5 cm / 28½ × 27 in
Collection of the artist

90
Rough Study. July 2nd 1991
Gouache and pencil on paper
68.5 × 91.3 cm / 26⅝ × 35½ in
Collection of the artist

91

Rough Study. July 4th 1991
Gouache and pencil on paper
66.6 × 91.5 cm / 26 × 35⅝ in
Collection of the artist

30
Justinian 1988
Oil on linen
165 × 226 cm / 65 × 89 in
Private Collection

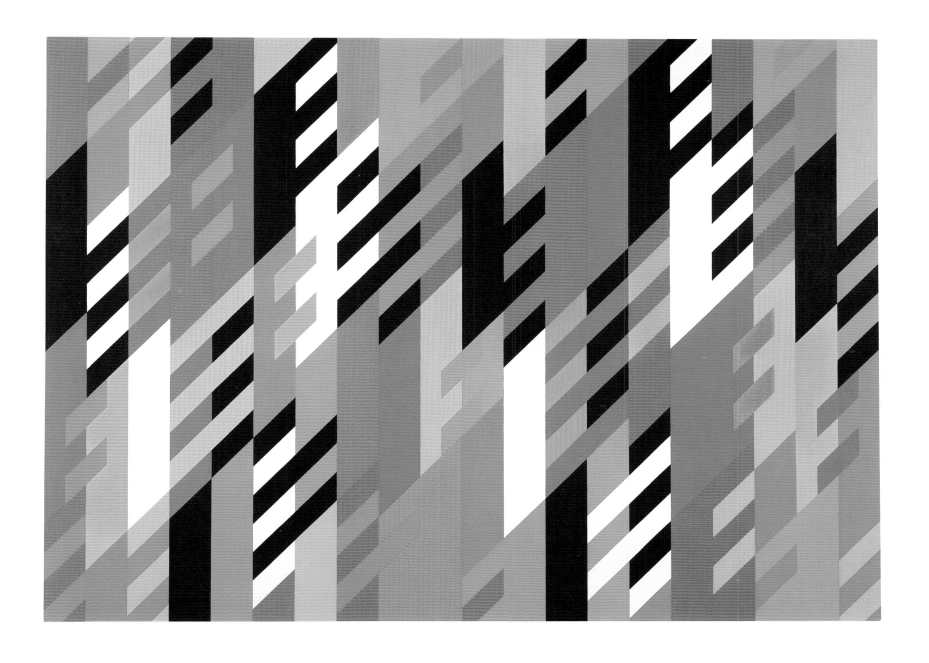

31
Reflection 2 1994
Oil on linen
165 × 228.4 cm / 65 × 90 in
Private Collection

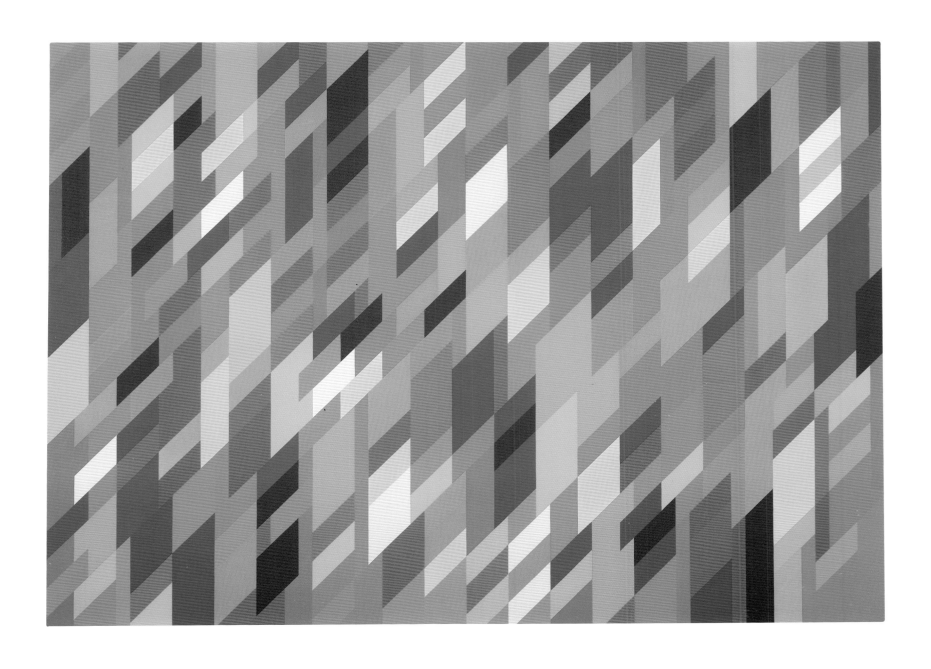

32
From Here 1994
Oil on linen
156.2 × 227.3 cm / 62 × 89⅝
Private Collection

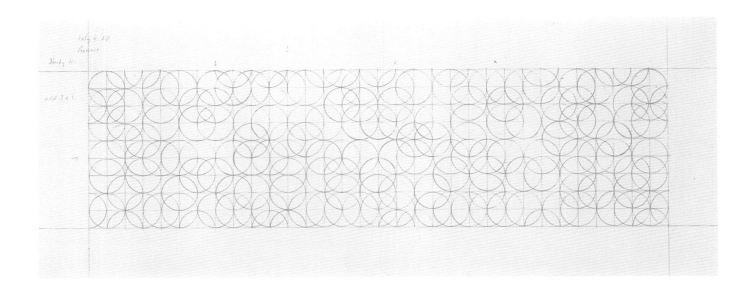

102

July 4 '00 Bassacs Study 11 for *Composition with Circles 2* 2000
Pencil on paper
38 × 96.5 cm / 14¾ × 37½ in
Collection of the artist

104
Sheet 2 Analysis of Study 11 for *Composition with Circles 2* 2000
Pencil on paper
36.5 × 96.5 cm / 14⅛ × 37½ in
Collection of the artist

33
Composition with Circles 2 2000
Acrylic on plaster wall
400 × 1370 cm / 157½ × 539⅜ in
Dia Art Foundation, New York
(illustrated overleaf, not exhibited)

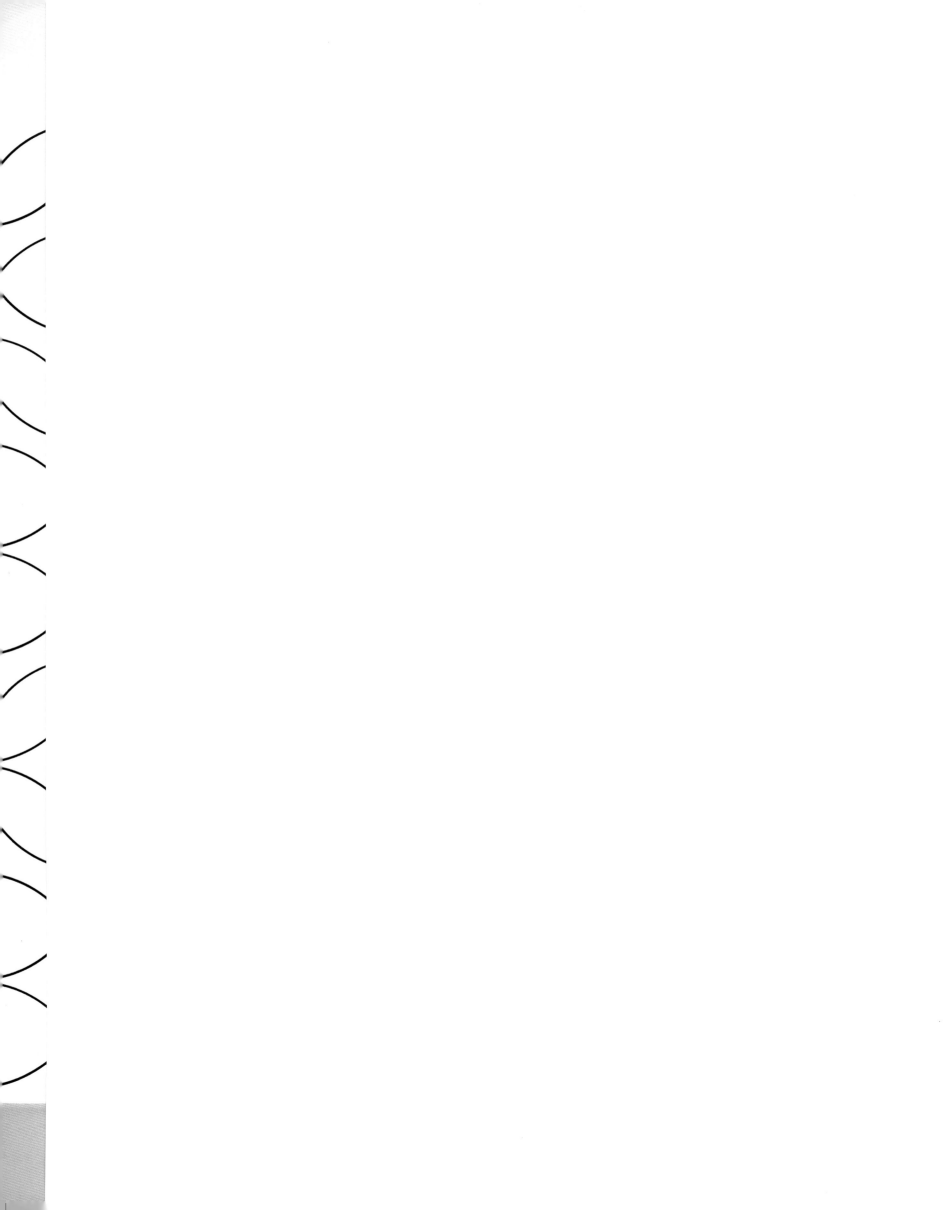

35
Lagoon 1 1997
Oil on linen
147 × 193 cm / 58 × 76 in
Private Collection

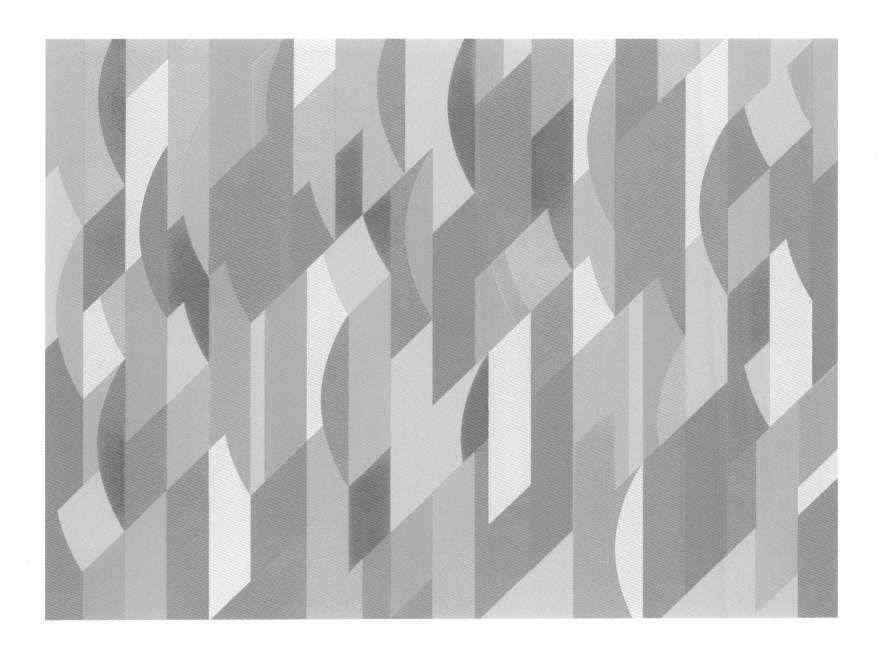

36
Rêve 1999
Oil on linen
228.3 × 238.1 cm / 89⅞ × 93¾ in
Private Collection

38
Evoë 3 2003
Oil on linen, two parts
193.4 × 579.8 cm overall / 76⅛ × 228⅛ in overall
Tate. Presented by Tate Members 2003

94
Red and Yellow Ground Study 1998
Gouache on paper
72.4 × 91.5 cm / 28½ × 35⅝ in
Collection of the artist

108
Tracing of Revision to *Parade 2* 2002
Pencil on tracing paper
37.5 × 83 cm / 14½ × 32⅜ in
Collection of the artist

107
Rough Study for *Yellows and Blues* 2002
Gouache on paper collage
47.5 × 91.5 cm / 18¾ × 36 in
Collection of the artist

106

Final Cartoon for *Apricot and Pink* 2001
Gouache on paper mounted on linen
129.5 × 228.5 cm / 50½ × 89 in
Collection of the artist

37
Parade 2 2002
Oil on linen, two panels
226.7 × 527.4 cm overall / 89¼ × 207⅝ in overall
Private Collection

Biographical notes
Compiled by Robert Kudielka

1931
Born in London.

1939–1945
Childhood in Cornwall. While her father is away in the armed forces during the War she lives with her mother, younger sister and aunt (a former student of Goldsmiths' College, London) in a cottage not far from the coast near Padstow. Irregular primary education by non-qualified or retired teachers who from time to time assemble children in the locality for lessons in subjects in which they have knowledge or interest. The beginning of Riley's interest in nature.

1946–1948
Education at Cheltenham Ladies' College. Thanks to an understanding headmistress she is allowed to organize her own curriculum, and chooses only art lessons in addition to obligatory subjects. Her teacher, Colin Hayes, later tutor at the Royal College of Art, London, introduces her to the history of painting and encourages her to attend the life class at the local art school. The Van Gogh exhibition at the Tate Gallery in 1947 is her first encounter with the work of a modern master.

1949–1952
Studies at Goldsmiths' College, London. For her entrance examination Riley submits, among other things, a copy of Van Eyck's *Man in a Turban*. She devotes herself mainly to the life-drawing class of Sam Rabin, who introduces her to the principles of pictorial abstraction: the autonomous construction of a body on a flat plane. She still remembers Rabin with respect, and later says: 'Life drawing was about the only thing I ever learned at art school.'

1952–1955
Studies at the Royal College of Art. A period of great frustration, partly because it is her first real experience of the art scene in London, partly because she slowly sees herself confronted with the unavoidable basic question of the modern painter: 'What should I paint, and how should I paint it?' Among her contemporaries are Frank Auerbach, Peter Blake, Robyn Denny, Richard Smith and Joe Tilson. She graduates with a BA degree.

1956–1958
Continuation of a long period of unhappiness. Nurses her father after a serious car accident and suffers a severe breakdown. Works in a glassware shop, teaches children and eventually joins the J. Walter Thompson Advertising Agency where her job is principally to draw the subjects which then formed the basis of the photographer's work. In the winter of 1958 she sees the Whitechapel Art Gallery's large Pollock exhibition, which makes a powerful impact.

1959
Stimulated by the exhibition *The Developing Process* at the Institute of Contemporary Arts, a joint project on the creative process devised by Harry Thubron and Victor Pasmore, she takes part in Thubron's summer school in Suffolk. There she meets Maurice de Sausmarez, who becomes her friend and mentor and who will write the first monograph on her work. The older painter and art scholar arouses her interest in Futurism and Divisionism and introduces her to primary documents of modern art (e.g. Klee, Stravinsky). In the late autumn she copies Georges Seurat's *Bridge at Courbevoie* from a reproduction.

First solo
exhibition at
Gallery One
1962

Earls Court
studio
1964

1960

First year of her independent work. In the summer she and
Maurice de Sausmarez tour Italy, admiring the architecture. At
the Venice Biennale, she sees the large exhibition of Futurism.
In the hills surrounding Siena she makes studies for *Pink
Landscape* 1960, a key painting in her early development. In the
autumn, she breaks with de Sausmarez and suffers a personal
and artistic crisis. From repeated attempts to make one final,
entirely black painting, originate her first black-and-white
works, which to begin with are oriented towards contemporary
Hard-Edge painting (e.g. *Kiss* 1961) but very quickly take on
the unmistakable traits of her own pictorial identity.

1961

Beginning of the black-and-white paintings which, with
ramifications, continue until 1966. It is a period of intense
work. The painter Peter Sedgley remains her partner
throughout the 1960s. In the summer they visit the plateau of
Vaucluse in the south of France where Riley acquires a derelict
farm which in the 1970s is transformed into her new studio. In
London, on her way home one evening from J. Walter
Thompson (where she works part-time until 1962 and remains
by a happy mistake on the payroll until 1964), she shelters
from a downpour in a doorway. It turns out to be the entrance
of Gallery One, whose director, Victor Musgrave, asks her in.
She invites him to visit her studio to look at her work. In the
following spring he hosts her first solo exhibition.

1965

Increasing recognition culminates in the inclusion of her work
in the exhibition *The Responsive Eye* at The Museum of Modern
Art, New York, in January. Richard Feigen simultaneously
opens a solo show of her work which is sold out before the
opening night. Josef Albers calls her his 'daughter' and Ad

Reinhardt acts as her escort, to protect her from 'wolves'. She
has become a 'star', to whom even Dalí pays tribute. But her
success is double-edged. Fashion shop windows are full of 'Op'
imitations of her work. With the help of Barnett Newman's
lawyer she tries to take legal action against this commercial
plagiarism, only to discover that in the USA there is no
copyright protection for artists. Leading New York artists,
realizing the dangerous implications of this, start their own
independent initiative. As a result in 1967 the first
US copyright legislation is passed. Returning to London three
weeks after the opening of *The Responsive Eye*, Riley has only
one thought: 'It will take at least twenty years before anyone
looks at my paintings seriously again.'

1965–1967

Period of transition in which she introduces into her painting
sequences of coloured greys, as opposed to the neutral greys
she had used earlier. The exceptional subtlety of these pictures
and their titles (*Arrest*, *Drift*, *Deny*) carry the method of reversal
further by compounding it. In the summer of 1967 she visits
Greece. In the same year, with *Chant 1* 1967 and *Late Morning*
1967–8, she makes her breakthrough to pure colour. Along
with the sculptor Phillip King she is chosen to represent Great
Britain at the forthcoming Venice Biennale. That winter she
meets Robert Kudielka for the first time.

1968–1969

Wins the International Prize for painting at the 34th Venice
Biennale. She is the first British contemporary painter and the
first woman ever to achieve this distinction. It is also the last
prize awarded by the Biennale in its old form. The prize-giving
ceremony cannot take place due to student protests. Along
with César, Marisol and others, she tries in vain to get into
discussion with the students. In the autumn of the same year

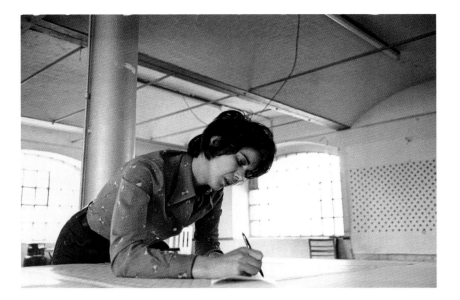

S.P.A.C.E. studio
in St Katherine's
Dock
1971

Sedgley and Riley establish S.P.A.C.E., an organization which provides artists with low-cost studios in large warehouse buildings. The project gets under way successfully with the move into St Katherine's Dock in 1969 and continues, with the support of the Arts Council of England, up to the present day.

1970–1971

Large European retrospective. It covers the period 1961–70 (including some work prior to 1961) and shows the development from the black-and-white works to the new colour paintings based on the interplay of only two or three colours. The exhibition opens at the Kunstverein Hannover, and subsequently travels to Bern, Düsseldorf, Turin and London, where it is extended and presented at the Hayward Gallery. It attracts more than 40,000 visitors. Robert Melville, who had so far followed her development rather critically, begins his review in the *New Statesman* with: 'No painter, dead or alive, has ever made us more aware of our eyes than Bridget Riley.'

1971–1973

Beginning of a period of radical change. After a final showing of her retrospective in Prague, she takes stock. Her visits to museums and art galleries while accompanying the exhibition have made her more curious about the European tradition in painting. She undertakes numerous journeys with Robert Kudielka: to see Tiepolo and Riemenschneider in Würzburg; Grünewald in Colmar. She visits the Alte Pinakothek in Munich, where she is deeply impressed by Altdorfer and Rubens, and the Prado in Madrid for the great Spanish painters and, above all, Titian. In such remote places as the Baroque churches of Upper Swabia in Germany she unexpectedly finds echoes of the luminous colours she is using at the time. All paths lead irresistibly and recurrently back to the vexing question occupying her in the studio: how to approach colour?

At first she tries to extend her means through formal changes, but with *Pæan* 1973 she changes the formal organization altogether, a move that anticipates the freer, more open structure of her work in the 1980s. In the spring of 1973, while looking at Altdorfer's cycle of the Passion in the convent of St Florian near Linz, news reaches her that her mother is suffering from an acute form of myeloma.

1974–1977

During the next two years she divides her time between London and Cornwall, where her parents have retired. She begins to read Proust, who influences her on many levels. She has her property in Vaucluse renovated, but does not use the newly-built studio until the beginning of the 1980s. With the 'curve' paintings, on which she worked exclusively between 1974 and 1978, her work takes a lyrical turn quite at odds with prevailing taste. Following the death of her mother in 1976 she concentrates on the preparation of another retrospective, and in connection with this she travels to Japan for three weeks at the end of March 1977, with a stopover in India where she visits the cave temples of Elephanta, Ellora and Ajanta. Her attraction to classical Japanese culture is spontaneous and ranges from painting and formal gardens through to Nô-theatre and the hospitality of the Ryokans. Kusuo Shimizu, the director of the Minami Gallery, Tokyo, gains her entrance to almost all the important sites in and around Kyoto and Nara. In the Osaka Museum she is given permission to examine Ogata Korin's famous sketchbook with his studies of waves.

1978–1980

A second retrospective exhibition, with just under a hundred paintings covering the years from 1959 to 1978, means that Riley travels extensively again. Opening in Buffalo, New York (September 1978), it continues with two further stops in the

West London studio at the time of the 'Egyptian' Series 1983

USA, two in Australia, and reaches its final destination in Tokyo (January 1980). In December 1977 she sees the exhibition *Cézanne: The Late Work* at The Museum of Modern Art, New York, visiting the show again in Paris the following year. In 1978 the exhibition *Monet's Years at Giverny: Beyond Impressionism* at the Metropolitan Museum, New York, engages her to such an extent that she goes to see it a second time in the autumn in St Louis. En route to the Sydney showing of her own exhibition she visits Tahiti. While in Australia she makes expeditions to the Barrier Reef, Alice Springs and Ayers Rock. She returns home via Indonesia: in Bali she enjoys the rich greens of the country and the extravagant colours of its festivals, especially the Barong theatre; and in Java she is particularly impressed by the pure, cool abstraction of the great temple of Borobudur in the middle of the jungle. Her artistic development takes an unexpected turn in the winter of 1979–80, when she travels, mainly on her sister's initiative, to Egypt. There she is taken by the contrast between the cultivation in the Nile Valley and the monumental works of art on the edge of the desert. In the Cairo Museum she is surprised by the consistent use of a certain group of colours in the arts and crafts of ancient Egypt; the tomb paintings on the West Bank of Luxor show her the full extent to which these colours could be developed. But it is only much later, after her return to London, that she recalls the particular palette and begins considering its potential for her own work.

1980–1985

The free reconstruction of the 'Egyptian palette' gives her for the first time a basic range of strong colours which, however, because of their intensity, demand a return to the simpler form of stripes. She begins to work regularly in her studio in Vaucluse and studies the use of colour by the French painters of classical Modernism. In 1981 she is appointed a trustee of the National Gallery in London. In the winter of 1981–2 she travels to Southern India where she visits the major Hindu and Buddhist monuments. In 1983, for the first time in fifteen years, she visits Venice to look at the paintings that form the basis of European colourism. She begins to give lectures on her work and accepts two commissions: in 1983 her wall paintings for the Royal Liverpool Hospital are completed, and in the same year, the Ballet Rambert gives a first performance at the Edinburgh Festival of the ballet *Colour Moves*, created by the American choreographer Robert North in response to her designs. During the planning of the extension of the National Gallery in London her role as a trustee becomes controversial. Almost single-handedly, she brings about the rejection of a commercial project for the new building and clears the way for the present Sainsbury Wing. In 1984 she gradually begins to prepare for a radical revision of her work in her Vaucluse studio, and in the spring of 1986 her painting takes a new direction.

1986–1991

In 1986, on the occasion of an exhibition in New York, she meets two postmodern 'appropriation' painters, Philip Taaffe and Ross Bleckner, who have made extensive use of her earlier work. She herself is moving into a new area. The breaking up of the vertical register of her paintings through the introduction of a dynamic diagonal disrupts the balance of her pictorial space and results in larger and smaller units in lozenge form. In order to be able to concentrate fully on the new work she sets up an additional studio in the East End of London. At the invitation of Wieland Schmied she runs a colour workshop at the 1987 Salzburg Summer Academy. In 1989 the National Gallery asks Riley to select the latest in the series of *The Artist's Eye* exhibitions. She chooses seven large figure compositions by Titian, Veronese, El Greco, Rubens, Poussin and Cézanne from

the Gallery's collection. They all have in common an organization shaped by diagonals and are characterized, if in varying degrees, by complex colour orchestrations.

1992–1995

In spring 1992 a retrospective, *Paintings 1982–1992*, opens at the Kunsthalle Nürnberg and travels to the Josef Albers Museum, Bottrop; the Hayward Gallery, London, with the subtitle *According to Sensation*; and the Ikon Gallery, Birmingham. It consists of paintings that cover the transition from the stripe formations to the dynamism of the lozenge structures. The success of the show coincides, particularly in England, with a series of exhibitions focusing on the art of the 1960s. Riley emerges as one of the few artists who were able subsequently to develop their work. The Tate Gallery in London puts on a Riley display, *Six Paintings 1963–1993*, drawn from its collection. As a result of the renewed interest in Riley's work BBC Radio 3 produces a series of five programmes in which Riley is in conversation with Neil MacGregor, E.H. Gombrich, Michael Craig-Martin, Andrew Graham-Dixon and Bryan Robertson. Broadcast in 1992, they are repeated the following year and published in book form in 1995. In 1993 she delivers her lecture, 'Colour for the Painter', at Darwin College in Cambridge. Riley is made Honorary Doctor of the Universities of Oxford (1993) and Cambridge (1995).

1995–1998

Her painting *From Here* 1984 lends its title to an exhibition of three generations of British abstract painters organized by Karsten Schubert and Waddington Galleries in 1995. After more than a thirty-year absence from teaching, Riley accepts an invitation to join the staff of De Montfort University, Leicester, as Visiting Professor. In 1996 she gives the 23rd William Townsend Memorial Lecture at the Slade School of Fine Art,

choosing 'Painting Now' as the subject. Visits to the Mondrian retrospective at the Gemeentemuseum in The Hague in the winter of 1994–5 lead to an intense re-engagement with the work and writings of Mondrian. In November 1995 she contributes a paper to a Mondrian symposium at the Museum of Modern Art, New York. The following year she is asked by the Tate Gallery to select a Mondrian exhibition from the collection of the Gemeentemuseum. Installed by Riley and her co-curator, Sean Rainbird, the exhibition is the first comprehensive Mondrian show in England in forty years. Meanwhile her own work is showing signs of further change. Having slowly introduced colour harmonies equal to the prevailing contrast structure, she is now working with a new sensation of 'depth'. In spring 1997 she also begins to introduce circular or curvilinear forms into her developed rhomboid structures, to more easily facilitate the looping arc-like movements of the colour organization. The renewed preoccupation with curves, and her interest in deep but not illusionistic pictorial space, lead to a large temporary wall drawing carried out for the *White Noise* exhibition at the Kunsthalle Bern in May 1998. The sensation of layered planes, previously achieved through complex colour relationships, is here the result of simple black-and-white drawing. The wall drawing has a major effect on her colour work. First results of this development are included in the exhibition *Bridget Riley: Works 1961–1998* shown at the Abbot Hall Art Gallery, Kendal (Cumbria), in winter 1998–9.

1999–2000

In the 1999 New Year's Honours, Riley is appointed a Companion of Honour. In June the exhibition *Bridget Riley: Paintings from the 1960s and 70s* opens at the Serpentine Gallery, London; on this occasion a collection of her writings and interviews, *The Eye's Mind: Bridget Riley, Collected Writings*

West London
studio
1998

1965–1999, is published. In October the exhibition *Ausgewählte Bilder/Selected Paintings 1961–1999* is shown in the Kunstverein in Düsseldorf. It makes a connection between the early black-and-white painting *Kiss* 1961 and *Rêve* 1999, the first fully achieved painting using the new curvilinear rhythm. In spring 2000 her biggest architectural commission to date is completed: a hanging, curtain-like installation in the atrium of Citibank's European headquarters in London designed by Norman Foster and Partners. Extending over eighteen floors it consists of three planes of coloured aluminium plates suspended by steel cables. Although related to her rhomboid paintings, this open construction changes according to the viewpoint from which it is seen and the conditions of light in the office tower. In the summer a group of her new curve paintings and related works on paper is shown in London for the first time at Waddington Galleries, an exhibition organised by Karsten Schubert. In the autumn the Dia Center for the Arts in New York mounts a survey of her work under the title *Bridget Riley: Reconnaissance*. The exhibition is complemented by a show of recent paintings at PaceWildenstein. Both shows mark a major re-evaluation of her work in America. At the end of November she takes part in the international symposium *Das Bild: Image, Picture, Painting* at the Berlin Academy of Arts.

2001–2002
Much of Riley's time in 2000–1 is taken up with the preparation of a Paul Klee exhibition for the Hayward Gallery in London (co-curated with Robert Kudielka). Riley participates in the Santa Fe biennial, *Beau Monde: Toward a Redeemed Cosmopolitanism 2001–2*, curated by Dave Hickey, with the painting *Evoë 1* 2000. The exhibition *Paul Klee: The Nature of Creation* is shown at the Hayward Gallery, London, in the spring of 2002. In March, *Bridget Riley: New Work* opens at the Museum Haus Esters and the Kaiser Wilhelm Museum, Krefeld,

the first museum show dedicated exclusively to the new curvilinear paintings.

2003–2004
The year 2003 is dominated by the preparation and installation of Riley's retrospective exhibition at Tate Britain (June 26–September 28). Together with curator Paul Moorhouse, she selects fifty-six paintings from all periods since 1961 and a group of preparatory studies which give an insight into her working methods. In the first room, she makes a special wall drawing of circles that link the early black-and-white work with her most recent paintings. The exhibition is received to universal critical acclaim and draws 98,000 visitors. One week after the opening, it is announced that Bridget Riley has been awarded the Praemium Imperiale, the prestigious international prize of the Japan Art Association, for her achievement as a painter. In October, she travels to Tokyo to attend the ceremony and delivers the message of thanks on behalf of the other laureates (Mario Merz, Ken Loach, Claudio Abbado and Rem Koolhaas). During this trip, she renews her acquaintance with some of the masterpieces of Japanese art. Also in 2003, Riley revisits the great museums of Munich and sees the big Titian exhibition at the Prado in Madrid. Another retrospective is selected for Australia and New Zealand – it will be shown at the Museum of Contemporary Art, Sydney, and the City Gallery Wellington in the winter of 2004–2005.

Exhibition history
Compiled by Robert Kudielka

Selected one-person exhibitions

1962	Gallery One, London
1963	Gallery One, London
1965	Richard Feigen Gallery, New York
	Feigen-Palmer Gallery, Los Angeles
1966	Drawings, Richard Feigen Gallery, New York
	Bridget Riley: Preparatory Drawings and Studies, Robert Fraser Gallery, London
1966–7	Bridget Riley: Drawings, The Museum of Modern Art, New York; touring to venues in the United States
1967	Richard Feigen Gallery, New York
	Robert Fraser Gallery, London
1968	Richard Feigen Gallery, New York
	34th Venice Biennale, British Pavilion (with Phillip King); touring to Städtische Kunstgalerie, Bochum; Museum Boijmans Van Beuningen, Rotterdam
1969	Rowan Gallery, London
	Drawings, Bear Lane Gallery, Oxford; Arnolfini Gallery, Bristol; Midland Group Gallery, Nottingham
1970–1	Bridget Riley: Paintings and Drawings 1951–71, Arts Council of Great Britain retrospective exhibition, Kunstverein Hannover; Kunsthalle Bern; Kunsthalle Düsseldorf; Galleria Civica d'Arte Moderna, Turin; Hayward Gallery, London; National Gallery, Prague
1971	Drawings, Rowan Gallery, London
1972	Kunstverein Göttingen
	Drawings, Rowan Gallery, London
1973	Bridget Riley: Paintings and Drawings 1961–1973, Arts Council of Great Britain exhibition, Whitworth Art Gallery, University of Manchester; Mappin Art Gallery, Sheffield; D.L.I. Museum and Arts Centre, Durham; Scottish National Gallery of Modern Art, Edinburgh; City Museum and Art Gallery, Birmingham; Museum and Art Gallery, Letchworth; City Art Gallery and Arnolfini Gallery, Bristol
1975	Galerie Beyeler, Basel
	Sidney Janis Gallery, New York
1976	Rowan Gallery, London
	Coventry Gallery, Sydney
1977	Minami Gallery, Tokyo
1978	Sidney Janis Gallery, New York
1978–80	Bridget Riley: Works 1959–78, British Council retrospective exhibition, Albright-Knox Art Gallery,

Buffalo; Dallas Museum of Fine Art; Neuberger Museum, Purchase, New York; Art Gallery of New South Wales, Sydney; Art Gallery of Western Australia, Perth; National Museum of Modern Art, Tokyo

1979	Drawings, Australian Galleries, Melbourne; Bonython Gallery, Adelaide
1980	Fruitmarket Gallery, Edinburgh; touring to venues in the United Kingdom
	Artline, The Hague
1980–2	Bridget Riley: Silkscreen Prints 1965–78, Preston Hall Museum, Stockton-On-Tees; touring to venues in the United Kingdom
1981	Recent Paintings and Gouaches, Rowan Gallery and Warwick Arts Trust, London
1982	Gouaches, Juda Rowan Gallery, London
1983	Bridget Riley: Paintings and Drawings 1981–83, Nishimura Gallery, Tokyo
1984	Bridget Riley: Project for the Royal Liverpool Hospital, Royal Institute of British Architects, London
1984–5	Galerie Reckermann, Cologne
	Working with Colour: Recent Paintings and Studies by Bridget Riley, Arts Council of Great Britain exhibition, D.L.I. Museum and Arts Centre, Durham; Huddersfield Art Gallery, Durham; Ferens Art Gallery, Hull; City Museum and Art Gallery, Stoke-on-Trent; Usher Gallery, Lincoln; City of Bristol Museum and Art Gallery; Towner Art Gallery, Eastbourne; Castle Museum, Norwich; Harris Museum and Art Gallery, Preston; York City Art Gallery; Mappin Art Gallery, Sheffield
1985	Bridget Riley: An Australian Context, Queensland Art Gallery, Brisbane
1986	Jeffrey Hoffeld Gallery, New York
1986–7	South Western Art Galleries Association in Scotland exhibition, Maclaurin Art Gallery, Ayr
1987	Galerie Konstructiv Tendens, Stockholm Galerie und Edition Schlégl, Zürich
	Bridget Riley: New Work, Mayor Rowan Gallery, London
1988	Galerie Teufel, Cologne
1989	Galerie und Edition Schlégl, Zürich
	Bridget Riley: Works on Paper, Mayor Rowan Gallery, London

1990	Sidney Janis Gallery, New York
	Nishimura Gallery, Tokyo
1992	Bridget Riley: Works on Paper 1982–1992, Karsten Schubert, London
	Bridget Riley: Paintings, Galerie Ascan Crone, Hamburg
1992–3	Bridget Riley: Paintings 1982–1992, Kunsthalle Nürnberg; Josef Albers Museum, Bottrop; Hayward Gallery, London; Ikon Gallery, Birmingham
1993	Bridget Riley: Colour Studies, Karsten Schubert, London
1994	Bridget Riley: Six Paintings 1963–1993, from the Collection, Tate Gallery, London
1995	Bridget Riley: Recent Paintings and Gouaches, Kettle's Yard, Cambridge University
	Bridget Riley: Recent Works – Paintings and Gouaches 1981–1995, Spacex Gallery, Exeter
	Bridget Riley: Gouaches 1980–1995, Aberdeen Art Gallery, Aberdeen
1996	Bridget Riley: Recent Paintings and Gouaches, Waddington Galleries and Karsten Schubert, London
	Bridget Riley: Gouaches 1980–1995, British School in Rome
	Bridget Riley: Paintings and Gouaches 1980–1995, Leeds City Art Gallery
	Bridget Riley: Museum für moderne Kunst des Landkreises Cuxhaven, Otterndorf
1997	Bridget Riley: Paintings, Gouaches and Prints 1981–1986, Green on Red Gallery Dublin
1988	Bridget Riley, Galerie Michael Sturm, Stuttgart
	Bridget Riley, Galerie Aurel Scheibler, Cologne
	Bridget Riley: Works 1961–1998, Abbot Hall Art Gallery, Kendal, Cumbria
1999	Bridget Riley: Paintings from the 1960s and 1970s, Serpentine Gallery, London
	Bridget Riley: Ausgewählte Bilder/Selected Paintings 1961–1999, Kunstverein für die Rheinlande und Westfalen, Düsseldorf
2000	Bridget Riley: New Paintings and Gouaches, Waddington Galleries, London (in collaboration with Karsten Schubert)
	Bridget Riley: Paintings 1982–2000 and Early Works on Paper, PaceWildenstein, New York
	Bridget Riley: Reconnaissance, Dia Center for the Arts, New York

2001 Bridget Riley: Complete Prints 1962–2001, Hayward
Gallery, London; toured to venues in the United
Kingdom through 2003

2002 Bridget Riley: New Work, Museum Haus Esters and
Kaiser Wilhelm Museum, Krefeld
Bridget Riley: Recent Paintings and Gouaches, Galerie
Michael Sturm, Stuttgart

2003 Bridget Riley, Galerie Beyeler, Basel
Bridget Riley, retrospective exhibition, Tate Britain,
London

Selected group exhibitions

1955 Young Contemporaries, RBA Galleries, London
1958 Diversion, South London Art Gallery, London
Some Contemporary British Painters, Wildenstein
Galleries, London
1962 Towards Art?, Arts Council of Great Britain
exhibition, Royal College of Art; touring to venues
in the United Kingdom
1963 1962, One Year of British Art, Tooths Gallery, London
John Moores Exhibition, Walker Art Gallery,
Liverpool
Ten Years, Gallery One, London
1964 The New Generation, Whitechapel Art Gallery,
London
Six Young Artists, Arts Council of Great Britain
exhibition; touring to venues in the United
Kingdom
Nouvelle Tendance, Musée des Arts Décoratifs, Paris
Marzotto Prize Exhibition, Italy; touring to venues
in Europe
Painting and Sculpture of a Decade, 1954–1964, Tate
Gallery, London
Carnegie International, Carnegie Institute,
Pittsburgh
Young Artists Biennale, Tokyo
1964–5 Contemporary British Painting and Sculpture, Albright-
Knox Art Gallery, Buffalo
Motion and Movement, Contemporary Arts Center,
Cincinnati
1965 The Responsive Eye, The Museum of Modern Art,
New York; touring to City Art Museum of St Louis;
Seattle Art Museum; Pasadena Art Museum;

Baltimore Museum of Art
John Moores Exhibition, Walker Art Gallery,
Liverpool
The Great Society: A Sampling of Its Imagery, Arts
Forum, Inc., Haverfort
A New York Collector Selects (Mrs Burton Tremaine),
San Francisco Museum of Modern Art
Pop and Op, Sidney Janis Gallery, New York
4th Biennale des Jeunes Artistes, Paris
Tel Aviv Museum

1965–6 London: The New Scene, Walker Art Center,
Minneapolis; touring to venues in Washington DC,
Boston, Seattle, Vancouver, Toronto and Ottawa
1966 Multiplicity, Institute of Contemporary Art, Boston
Aspects of New British Art, Auckland; touring to
venues in New Zealand and Australia
London under Forty, Galleria Milano, Milan
English Graphic Art, Galerie der Spiegel, Cologne
Painting and Sculpture 1966, Fireside Lounge Gallery,
University of Wisconsin, Milwaukee
1967 Drawing Towards Painting 2, Arts Council, London;
touring to venues in the United Kingdom
Op Art, Londonderry, Dublin and Belfast
British Drawings, The Museum of Modern Art, New
York; touring to venues in the United States
Carnegie International, Carnegie Institute,
Pittsburgh
Premio International Escultura, Instituto di Tella,
Buenos Aires
Acquisitions of the Sixties, The Museum of Modern
Art, New York
Recent British Painting from the Collection of Peter
Stuyvesant Foundation, New York, Tate Gallery, London
English and American Graphics '67 (from The Museum
of Modern Art, New York), Belgrade; touring to
venues in Yugoslavia
Jeunes Peintres Anglais, Palais des Beaux-Arts, Brussels
1968 The New Generation: Interim Exhibition, Whitechapel
Art Gallery, London
Britische Kunst Heute, Hamburger Kunstverein
European Painters of Today, Musée des Arts
Décoratifs, Paris; touring to venues in the United
States
20th Century Art, Fondation Maeght, Saint Paul
de Vence

New British Painting and Sculpture, organized by
Whitechapel Art Gallery, London; touring to venues
in the United States and Canada
Plus by Minus: Today's Half Century, Albright-Knox
Art Gallery, Buffalo
Junge Generation Großbritannien, Akademie der
Künste, Berlin
Leicestershire Education Authority Collection Part 2,
Whitechapel Art Gallery, London
Graphics Exhibition, Museum of Modern Art, Oxford
Documenta IV, Kassel
British Artists: 6 Painters, 6 Sculptors, The Museum of
Modern Art, New York; touring to venues in the
United States

1969 Phillip King: Beelden. Bridget Riley: Schilderijen en
tekeningen, Museum Boijmans Van Beuningen,
Rotterdam
Contemporary Art: Dialogue between East and West,
National Museum of Modern Art, Tokyo
Marks on Canvas, Museum am Ostwall, Dortmund,
and Kunstverein Hannover
Black White, Smithsonian Institution, Washington
DC; touring to venues in the United States

1970 Contemporary Paintings from the Sebastian de Ferranti
Collection, Whitworth Art Gallery, Manchester

1971 ROSC '71, Royal Dublin Society, Dublin

1972 8th International Print Biennial, National Museum
of Modern Art, Tokyo, and the National Museum of
Modern Art, Kyoto

1973 La peinture anglaise aujourd'hui, Musée d'Art Moderne
de la Ville de Paris
Henry Moore to Gilbert and George: Modern British
Art from the Tate Gallery, Palais des Beaux-Arts,
Brussels

1974 British Painting '74, Hayward Gallery, London
Graveurs Anglais Contemporains, Musée d'Art et
d'Histoire, Cabinet des Estampes, Geneva

1975 Contemporary British Drawings, 12th Biennale de São
Paulo
From Britain '75, Taidehalli, Helsinki

1976 Art as Thought Process, 11th Biennale International
d'Art, Palais de l'Europe, Menton
Contemporary British Art, Galleries of Cleveland
Institute of Art
Arte inglese oggi, Palazzo Reale, Milan

1977 Documenta VI, Kassel
 Biennale de Paris, une anthologie: 1959–1967, Paris
 British Artists of the '60s, Tate Gallery, London
 Less is More, Sidney Janis Gallery, New York
 12th International Exhibition of Graphic Art,
 Ljubljana
 Contemporary Drawing, Art Gallery of Western
 Australia, Perth

1977–8 Recent British Art, British Council exhibition;
 touring to venues in Yugoslavia, Greece, Austria,
 Poland, Sweden, Norway and Finland

1978 The Mechanised Image, Arts Council of Great Britain
 exhibition, City Museum and Art Gallery,
 Portsmouth; touring to venues in the United
 Kingdom
 Recent British Art, Nordjyllands Kunstmuseum,
 Aalborg

1979 British Drawings since 1945 in the Whitworth Art
 Gallery, Whitworth Art Gallery, Manchester

1979–80 Peter Moores Liverpool Project 5: The Craft of Art,
 Walker Art Gallery, Liverpool

1982 Aspects of British Art Today, Arts Council of Great
 Britain exhibition touring Japan; Tokyo
 Metropolitan Museum; Tochigi Prefectural
 Museum; National Museum of Modern Art, Osaka;
 Fukuoka Art Museum; Hokkaido Museum of
 Modern Art, Sapporo

1984 A Different Climate, Kunsthalle Düsseldorf
 Artists Design for Dance 1909–1984, Arnolfini
 Gallery, Bristol

1985 Hayward Annual: 25 Years – Three Decades of
 Contemporary Art: The Sixties, the Seventies and
 the Eighties, Annely Juda Fine Art, London

1986 The Heroic Sublime, Charles Cowles Gallery, New York
 42nd Venice Biennale

1987 British Art in the 20th Century, Royal Academy,
 London; Staatsgalerie, Stuttgart

1988 Exhibition Road: Painters at the Royal College of Art,
 Royal College of Art, London

1988–9 Viewpoints: Postwar Painting and Sculpture from the
 Guggenheim Museum Collection and Major Loans,
 Guggenheim Museum, New York; touring to
 venues in the United States
 The Presence of Painting: Aspects of British Abstraction
 1957–1988, South Bank Centre, London;

 Mappin Art Gallery, Sheffield; Hatton Gallery,
 Newcastle; Ikon Gallery, Birmingham

1989 The Experience of Painting: Eight Modern Artists, South
 Bank Centre, London; Laing Art Gallery,
 Newcastle upon Tyne; Mappin Art Gallery,
 Sheffield; City Art Gallery, Stoke-on-Trent

1990 Künstlerinnen des 20. Jahrhunderts, Museum
 Wiesbaden

1992–3 Ready Steady Go: Paintings of the Sixties from the Arts
 Council Collection, South Bank Centre, London;
 touring to venues in the United Kingdom

1993 New Realities 1945–1968, Tate Gallery, Liverpool

1994 Group Show, Karsten Schubert Gallery, London
 British Abstract Art Part 1: Painting, Flowers East,
 London

1995 Drawing the Line, South Bank Centre, London;
 toured venues in the United Kingdom
 From Here, Waddington Galleries and Karsten
 Schubert, London
 Patrick Heron, Bridget Riley: Colour and Nature, Castle
 Museum, Norwich
 Karo Dame, Kunstmuseum, Aarau
 Artist's Choice: Elizabeth Murray – Modern Women, The
 Museum of Modern Art, New York

1996 British Abstract Art Part III: Works on Paper, Flowers
 East, London

1997 Treasure Island, Centro de Arte Moderna José de
 Azeredo Perdigiao, Lisbon
 A Quality of Light, Tate Gallery, St. Ives

1998 White Noise, Kunsthalle Bern

1999 '45 – '49, Kettle's Yard, Cambridge University;
 toured to venues in the United Kingdom
 Sublime: The Darkness and the Light – Works from the
 Arts Council Collection, John Hansard Gallery,
 Southampton; toured to venues in the United
 Kingdom

2000 Collection 2000, Tate Modern, London
 Blue, New Art Gallery, Walsall
 Beau Monde: Toward a Redeemed Cosmopolitan,
 4th International Biennial, Site Santa Fe

2002 Good Vibrations: The Legacy of Op Art in Australia,
 Heide Art Museum, Victoria
 From Blast to Freeze: British Art in the 20th Century,
 Kunstmuseum Wolfsburg

2003 Biennale d'Art Contemporain, La Sucrière, Lyons

Other activities

1965 Design of the background projection for T.S. Eliot's
 Sweeney Agonistes at the Eliot Memorial Performance

1974 Mural for Morley College, London

1980–3 Royal Liverpool Hospital project

1983 Design for the backcloth for Colour Moves,
 performed by the Ballet Rambert at the Edinburgh
 Festival

1986–7 St Mary's Hospital project, London

1988 Commission for ICI, Millbank, London

1989 The Artist's Eye, Bridget Riley, National Gallery,
 London

1996 Piet Mondrian: From Nature to Abstraction, Tate
 Gallery, London, co-curated with Sean Rainbird

1998–2000
 Commission for Foster & Partners' Citibank
 Building, Canary Wharf, London

2002 Paul Klee: The Nature of Creation, Hayward Gallery,
 London, co-curated with Robert Kudielka

Bibliography
Compiled by Robert Kudielka

Writings and interviews by the artist

The Eye's Mind: Bridget Riley. Collected Writings 1965–1999, ed. Robert Kudielka, London: Thames and Hudson, in association with Serpentine Gallery, London, and De Montfort University, Leicester, 1999
German translation: *Malen um zu sehen: Bridget Riley. Gesammelte Schriften 1965–2001*, ed. Robert Kudielka, Krefelder Kunstmuseen and Hatje Cantz Verlag, 2002 (extended by German translations of 'Conversation with Isabel Carlisle', 1998, and 'Supposed to be Abstract', 2002)

The Eye's Mind includes all important writings and authorized interviews since 1965 except the following:

'Jenseits von Op-Art: Bridget Riley im Gespräch', interview by Robert Kudielka, *Das Kunstwerk*, vol. 22, nos. 3–4, December 1968–January 1969, pp. 15–25
'On Travelling Paintings', *Art Monthly*, vol. 5, no. 39, September 1980, pp. 5–9
'Bridget Riley interviewed', by Andrew Smith, *Arts Review*, vol. 33, no. 11, 5 June 1981, p. 228
'Hospital treatment', interview by Douglas Stephen, *Building Design*, 7 September 1984
'Henri Matisse, The Dance', *Daily Telegraph* magazine, 27 October 1990
'Bridget Riley: Visual Fabric', interview by James Roberts, *Frieze*, no. 6, September–October 1992, pp. 20–3
'Bridget Riley – Some things near and some far', conversation with Andrew Renton, *Flash Art*, vol. 26, no. 168, January–February 1993, pp. 59–61
'On Picasso', part of a collection of statements titled 'Artists on Picasso', ed. Helen Hague, *The Sunday Times*, 20 February 1994
'Bridget Riley on The Snail', *Daily Telegraph* magazine, 20 December 1997
Bridget Riley: Dialogues on Art. With Michael Craig-Martin, Andrew Graham-Dixon, Ernst H. Gombrich, Neil MacGregor and Bryan Robertson, ed. Robert Kudielka. Introduction by Richard Shone, London: Zwemmer, 1995 (reprinted London: Thames and Hudson, 2003)
'Bridget Riley – Musing on Poussin', *Independent*, 20 January 1995

'Colour for the Painter', *Colour: Art and Science*, ed. Trevor Lamb and Janine Bourriau, Cambridge: Cambridge University Press, 1995, pp. 31–64
'Conversation with Bridget Riley', by Isabel Carlisle, *Bridget Riley: Works 1961–1989*, Kendal, Cumbria: Abbot Hall Art Gallery and Museum, 1998, pp. 7–10
'She's a dedicated follower of abstraction', interview with David Thompson, *Independent on Sunday*, 15 November 1998
'Supposed to be abstract – Bridget Riley in conversation with Robert Kudielka' (English–German), *Parkett*, no. 61, May 2001, pp. 20–51
'Making Visible', *Paul Klee: The Nature of Creation*, London: Hayward Gallery in association with Lund Humphries, 2002, pp. 15–19

Catalogues and books

Bridget Riley, London: Gallery One, 1962. Text by Maurice de Sausmarez
Bridget Riley, London: Gallery One, 1963. Texts by Anton Ehrenzweig and David Sylvester
The New Generation, London: Whitechapel Gallery, 1964. Text by David Thompson
Bryan Robertson, John Russell and Lord Snowdon, *Private View*, London: Thomas Nelson and Sons, 1965
London: The New Scene, Minneapolis: Walker Art Center in association with the Calouste Gulbenkian Foundation and The British Council, 1965. Texts by Martin Friedman and Alan Bowness
The English Eye, New York: Marlborough-Gerson Gallery, 1965. Texts by Bryan Robertson and Robert Melville
The Responsive Eye, New York: The Museum of Modern Art, 1965. Text by William Seitz
Poor Old Tired Horse 18, Gledfield Farmhouse, Ardgay: Wild Hawthorn Press (Ian Hamilton Finlay), 1966. Drawings and layout by Bridget Riley, writings and script by Ad Reinhardt
Bridget Riley: Drawings, New York: The Museum of Modern Art, 1966. Text by Jennifer Licht
Michael Compton, *Optical and Kinetic Art*, London: Tate Gallery Publications, 1967
Bridget Riley. The 34th Venice Biennale, London: The British Council, 1968. Text by David Thompson

A Dialogue: New British Painting and Sculpture, Los Angeles: UCLA Galleries, 1968. Texts by Herbert Read and Bryan Robertson
Op Art und Kinetik, Kassel: Documenta IV, 1968. Text by Werner Spies
Bridget Riley: Working Drawings, Oxford: Bear Lane Gallery, 1969. Text by Maurice de Sausmarez
Marks on Canvas, Dortmund: Museum am Ostwall, 1969. Text by Anne Seymour
Cyril Barrett, *Op Art*, London: Studio Vista, 1970
Maurice de Sausmarez, *Bridget Riley*, London: Studio Vista, 1970
Bridget Riley, Kunstverein Hannover, 1970. Texts by Manfred de la Motte and Bryan Robertson. Catalogue of the retrospective exhibition, reprinted with different layouts and additional texts at the following venues: Kunsthalle Bern, 1970. Texts by Carlo Huber and Bryan Robertson
Kunsthalle Düsseldorf, 1970. Texts by Carl Ruhrberg, Wieland Schmied and Bryan Robertson
Galleria Civica d'Arte Moderna Turin, 1971. Text by Bryan Robertson
Bridget Riley: Paintings and Drawings 1951–71, London: Hayward Gallery, in association with Arts Council of Great Britain 1971. Text by Bryan Robertson. Extended version and catalogue of the 1970–1 European retrospective
British Painting '74, London: Arts Council of Great Britain and Hayward Gallery, 1974
Bridget Riley, New York: Sidney Janis Gallery, 1975. Text by David Thompson
Bridget Riley, Basel: Galerie Beyeler, 1975. Text by Bryan Robertson
Arte inglese oggi 1960–76, Milan: Electa Editrice, 1976, 2 vols. Texts by Norbert Lynton and David Thompson
Recent British Art, London: The British Council, 1977. Text by David Thompson
Bridget Riley: Works 1959–1978, London: The British Council, 1978. Text by Robert Kudielka. Catalogue of the retrospective exhibition shown in Albright-Knox Art Gallery, Buffalo; Dallas Museum of Fine Art; Art Gallery of New South Wales, Sydney; Art Gallery of Western Australia, Perth; Neuberger Museum, Purchase, New York; and National Museum of Modern Art, Tokyo (1980), where a Japanese version was published

Bridget Riley: Silkscreen Prints 1965–1978, London: Arts Council of Great Britain, 1980. Text by Robert Kudielka

Working with Colour: Recent Paintings and Studies by Bridget Riley, London: Arts Council of Great Britain, 1984. Text by Robert Cumming

Bridget Riley: Ölbilder und Gouachen, Cologne: Galerie Reckermann, 1984. Text by Robert Kudielka

Bridget Riley: An Australian Context, Brisbane: Queensland Art Gallery, 1985. Text by Jenny Harper

Karina Türr, Op Art. Stil, Ornament oder Experiment?, Berlin: Gebr. Mann Verlag, 1986

'Bridget Riley', The Great Artists: Their Lives, Works and Inspiration, vol. 4, part 86, London: Marshall Cavendish Ltd., Twentieth Century Series, 1986

British Art in the 20th Century. The Modern Movement, ed. Susan Compton, London: Royal Academy of Art, in association with Prestel-Verlag, Munich, 1986 (German edition 1987)

Bridget Riley, New York: Sidney Janis Gallery, 1990. Conversation with Robert Kudielka

Künstlerinnen des 20. Jahrhunderts, Museum Wiesbaden, 1990. Text by Karl Ruhrberg

Bridget Riley: Paintings 1982–1992, London: The Hayward Gallery, in association with Verlag für Moderne Kunst, Nürnberg, 1992. Texts by Lucius Grisebach and Robert Kudielka (German and English edition)

Bridget Riley: Works on Paper 1980–1992, London: Karsten Schubert, 1992

The Sixties Art Scene in London, London: Phaidon Press, in association with Barbican Art Gallery, 1993. Text by David Mellor

Colour and Nature: Patrick Heron and Bridget Riley, Norwich Castle Museum, 1995. Text by Andrew Moore

Bridget Riley: Recent Paintings and Gouaches 1981–1995, London: Waddington Galleries and Karsten Schubert, in association with Spacex Gallery, Exeter, 1996. Text by Richard Shone. Conversation with Alex Farquharson

Bridget Riley: Works 1961–1998, Kendal, Cumbria: Abbot Hall Art Gallery, 1998. Conversation with Isabel Carlisle

Bridget Riley: Selected Paintings 1961–1999, Ostfildern: Hatje Cantz, in association with Kunstverein für die Rheinlande und Westfalen, Düsseldorf, 1999. Texts by Michael Krajewski, Robert Kudielka and Raimund Stecker. German translation of the artist's conversations with Ernst H. Gombrich and Michael Craig-Martin from Bridget Riley: Dialogues on Art

Bridget Riley: Paintings from the 1960s and 70s, London: Serpentine Gallery, 1999. Texts by Lisa Corrin, Robert Kudielka and Frances Spalding

Bridget Riley: New Paintings and Gouaches, London: Waddington Galleries, in association with Karsten Schubert, 2000. Text by Lynn MacRitchie

Bridget Riley: Reconnaissance, New York: Dia Center for the Arts, 2000. Texts by Lynne Cooke and John Elderfield

Bridget Riley: Paintings 1982–2000 and Early Works on Paper, New York: PaceWildenstein, 2000. Text by Dave Hickey

Beau Monde: Toward a Redeemed Cosmopolitanism, Site Santa Fe, 2002. Curated by Dave Hickey. Texts by Louis Grachos and Dave Hickey

Bridget Riley. New Work, Stuttgart: Hatje Cantz, 2002. Texts by Martin Hentschel and Lynn MacRitchie

Bridget Riley: Complete Prints 1962–2001, London: Ridinghouse, 2002. Catalogue raisonné by Karsten Schubert. Texts by Craig Hartley and Lynn MacRitchie

Blast to Freeze: British Art in the 20th Century, ed. Henry Meyric Hughes and Gijs van Tuyl, Ostfildern: Hatje Cantz, in association with Kunstmuseum Wolfsburg, 2002

Bridget Riley, Basel: Galerie Beyeler, 2003. Conversation with Isabel Carlisle (English and German edition)

Artiicles and reviews

Michael Shepherd, 'Bridget Riley', Arts Review, vol. 14, no. 8, 5–19 May 1962, p. 19

David Sylvester, 'Bridget Riley', New Statesman, 25 May 1962

Norbert Lynton, 'London Letter, Bridget Riley', Art International, Lugano, vol. 6, no. 7, September 1962, p. 47

Edward Lucie-Smith, 'Round the Galleries, Assemblages', Listener, 7 February 1963, p. 254

Jasia Reichardt, 'Bridget Riley', Architectural Design, vol. 8, no. 354, August 1963

Norbert Lynton, 'London Letter, Riley', Art International, Lugano, vol. 7, no. 8, October 1963, p. 84

John Russell, 'Art News from London, Riley', Artnews, vol. 62, no. 7, November 1963, p. 47

'Bridget Riley', Time Magazine, 1 May 1964 (Atlantic Edition), p. 75

Robert Melville, 'The New Generation', Architectural Review, vol. 135, no. 808, June 1964, pp. 447–9

Ion Borgzinner, 'Op Art. Pictures that attack the Eye', Time Magazine, 23 October 1964, pp. 78–86

'Op Art', Life Magazine, 11 December 1964 (only illustrations)

'Op Art', Life International, 28 December 1964 (Warren R.Young, 'Bringing Chaos out of Order', pp. 60–2).

Anton Ehrenzweig, 'The Pictorial Space of Bridget Riley', Art International, Lugano, vol. 9, no. 1, February 1965, pp. 20–4

John Canaday, 'The Responsive Eye. Three Cheers and High Hopes', New York Times, 28 February 1965

John Canaday, 'That's Right It's Wrong', New York Times, 14 March 1965

Thomas B. Hess, 'You can hang it in the hall', Artnews, vol. 64, no. 2, April 1965, pp. 41–3

Anne Ryan, 'Top Op Artist', Women's Wear Daily, 11 May 1965

Rosalind Krauss, 'Afterthoughts on "Op"', Art International, Lugano, vol. 9, no. 5, June 1965, pp. 75–6

Elwyn Lynn, 'Op', Vogue Australia, vol. 9, no. 6, 1965, pp. 78–9

Prudence Fay, 'Op-position', Queen, 5 January 1966

Rosalind Krauss, 'Exhibition at Feigen Gallery, New York', Artforum, vol. 4, no. 10, June 1966, pp. 51–2

Gene Baro, 'Bridget Riley: Drawing for Painting', Studio International, vol. 172, no. 879, July 1966, pp. 12–13

Jack W. Burnham, 'The Art of Bridget Riley', Triquarterly 5, Evanston, Illinois, 1966

John Russell, 'Double Portrait: Bridget Riley and Phillip King', Art in America, vol. 55, no. 3, May–June 1967, pp. 98–102

Anthony Tucker, 'Something in Common', Shell Magazine, June 1967

Michel Claura, 'La Jeune peinture en Grande-Bretagne', Lettres Françaises, 17 January 1968

Norbert Lynton, 'The British Representation at the 34th Venice Biennale', Art International, Lugano, vol. 12, no. 6, Summer 1968, pp. 74–5

David Thompson, 'British Artists at Venice I: The Paintings of Bridget Riley', Studio International, vol. 175, no. 901, June 1968, pp. 295–9

John Russell, 'Venice is a Battlefield: Art the Loser', The Sunday Times, 23 June 1968

Edward Lucie-Smith, 'Bridget Riley's Venice Success', The Times, 29 October 1968

Gene Baro, 'Bridget Riley's Nineteen Greys', Studio International, vol. 176, no. 906, December 1968, pp. 280–1

David Thompson, 'Bridget Riley and Her Safe Roller Coaster', New York Times, 29 December 1968

Maurice de Sausmarez, 'Bridget Riley: working drawings', Art and Artists, vol. 4, no. 2, May 1969, p. 29

Pat Gilmour, 'Bridget Riley', Arts Review, vol. 21, no. 14, 19 July 1969, p. 465

Edwin Mullins, 'Riley in Colour', Sunday Telegraph, 20 July 1969

Ian Dunlop, 'Colour and Size make Riley's Art Different', Evening Standard, 21 July 1969

Guy Brett, 'Optical Energy Subtly Used', The Times, 25 July 1969

Norbert Lynton, 'Bridget Riley Turns to Colour', Guardian, 29 July 1969

Robert Hughes, 'Perilous Equilibrium', Time Magazine, 16 November 1970, p. 82

Peter Winter, 'Der fluktuierende Raum. Bridget Rileys grosse Retrospektive in Hannover', Frankfurter Allgemeine Zeitung, 7 December 1970

Robert Kudielka, 'Bridget Riley', Das Kunstwerk, vol. 24, no. 2, March 1971, pp. 114–15

Andrew Forge, 'On looking at paintings by Bridget Riley', Art International, Lugano, vol. 15, no. 3, March 1971, pp. 16–21

Helga Meister, 'Ein Fest der Farben. Die englische Op-Künstlerin Bridget Riley in Düsseldorf', Düsseldorfer Nachrichten, 13 March 1971

Yvonne Friedrichs, 'Die visuelle Zeit. Bridget Riley in der Düsseldorfer Kunsthalle – Vitalität in geometrischen Rastern', Rheinische Post, 15 March 1971

Günter Pfeiffer, 'Farbe vibriert wie gezupfte Saiten. Die Op-Art stammt vom Impressionismus ab: Zur grossen Retrospektive der englischen Malerin Bridget Riley in Düsseldorf', Kölner Stadtanzeiger, 6 April 1971

Luigi Carluccio, 'Con Bridget Riley arriva la magia dell'arte "op"', Gazetta del Popolo, Turin, 27 May 1971

Hilary Spurling, 'Bridget Riley's Colour Explosion', The Times, 21 July 1971

Robert Melville, 'An Art Without Accidents', New Statesman, 23 July 1971, p. 121

Nigel Gosling, 'Fearless on the Frontier', Observer, 25 July 1971

John Russell, 'Riley's Line', The Sunday Times, 25 July 1971

Peter Fuller, 'Bridget Riley', Arts Review, vol. 23, no. 15, 31 July 1971, p. 459

David Thompson, 'Bridget Riley', Studio International, vol. 182, no. 935, July–August 1971, pp. 16–21.

Michael Shepherd, 'Writing on Riley', Sunday Telegraph, 1 August 1971

Richard Cork, 'What has happened to this Woman's Eye-Bullying Art', Evening Standard, 5 August 1971

Pierre Rouve, 'Bridget Riley Drawings', Arts Review, vol. 24, no. 12, 17 June 1972, p. 356

Daniel Marchesseau, 'La Révélation de Bridget Riley', Les Gullivériens, March 1973

Bryan Robertson, 'Colour as Image', Art in America, vol. 63, no. 2, March–April 1975, pp. 69–71

Tom Wolfe, 'The Painted Word', Harpers Magazine, April 1975

Robert Hughes, 'Making waves', Time Magazine, 12 May 1975, pp. 52–3

Roberta Smith, 'Reviews (Bridget Riley exhibition at Sidney Janis)', Artforum, vol. 14, no. 1, September 1975, p. 71

John Spurling, 'Mind's Eye', New Statesman, 16 July 1976

Itsuo Sakane, 'Op Art', Asahi Shimbun, 25 July 1976

Sandra McGrath, 'Art', The Australian, 23 November 1976

Elwyn Lynn, 'Henry Moore, Francis Bacon and Bridget Riley', Art in Australia, vol. 14, nos. 3–4, January–April 1977, pp. 302–7

John Russell, 'Bridget Riley's show in Buffalo', The Times, 15 November 1978

'Bridget Riley', interview by John Gruen (1978), reprinted in John Gruen, The Artist Observed. 28 Interviews with Contemporary Artists, Chicago: capella books and Chicago Review Press, 1991, pp. 150–9

John Russell, 'The Cogency of Riley', New York Times, 28 January 1979

Lois Hunter, 'Imitation does not flatter', POL, Australia, September 1979

Barbara Thoren, 'The Week in Art: Bridget Riley', Japan Times, 6 February 1980

Robert Hughes, 'The Shock of the New VIII: The Age of the New has entered history', Listener, 13 November 1980

Edward Lucie Smith, 'The World of Bridget Riley', Illustrated London News, June 1981

John Russell Taylor, 'Consistent organic growth from optical illusion', The Times, 16 June 1981

Stephen Gardiner, 'An electric array of stripes', Observer, 17 July 1983

Roger Berthoud, 'Shining visions of an abstract future', The Times, 31 August 1983

David Dougill, 'Dancing down Riley's rainbow', The Sunday Times, 4 September 1983

William Packer, 'Putting across the message', Financial Times, 6 March 1984

Hans Peter Riese, 'Bridget Riley', Die Zeit, Hamburg, 30 November 1984

Carlo McCormick, 'poptometry', Artforum, vol. 24, no. 3, November 1985, pp. 87–91

John Russell, 'Bridget Riley', New York Times, 10 October 1986

Calvin Tomkins, 'Between Neo- and Post-', New Yorker, 24 November 1986

Karina Türr, 'Jenseits von Op Art? Überlegungen zu den Farbstreifen Bridget Rileys', Pantheon, International Annual Art Journal, vol. 44, 1986, pp. 157–63

Ludmilla Vachtova, 'Ruhe in feinster Bewegung', Tages-Anzeiger, Zürich, 30 January 1987

Larry Berryman, 'Bridget Riley', Arts Review, vol. 39, no. 13, 3 July 1987, p. 456

'Op Art. Special Feature on Bridget Riley', art & man (Scholastic under the direction of the National Gallery of Art, Washington DC), vol. 18, no. 5, March 1988

Andrew Graham-Dixon, 'Between the lines', Independent, 13 May 1989

Larry Berryman, 'Bridget Riley: Works on Paper 1978–1980 (Mayor Rowan Gallery) and The Artist's Eye (National Gallery)', Arts Review, vol. 41, no. 15, July 1989, pp. 572–3

Laurence Marks, 'The Life of Riley', Observer magazine, 2 July 1989

Richard Dorment, 'The colour of greatness', Daily Telegraph, 7 July 1989

Brian Sewell, 'Eye for Figures', Evening Standard, 20 July 1989

William Packer, 'Form passive, colour active', Financial Times, 25 July 1989

John Cunningham, 'A new optical nerve', Guardian, 28 July 1989

Peter Fuller, 'Hysteria as a hole in the head', Sunday Telegraph, 6 May 1990

Terry R. Myers, 'Bridget Riley at Sidney Janis', Art in America, vol. 78, no. 9, September 1990, pp. 199–200

Frank Whitford, 'Still groovy after all these years', The Sunday Times, 26 January 1992

Hans Pietsch, 'Meine Bilder sollen in sich selber ruhen', ART, Hamburg, April 1992

Walter Fenn, 'Die Tektonik farbiger Rauten', Nürnberger Nachrichten, 8 April 1992

Thomas Kliemann, 'Nürnberg: Bridget Riley mit Bildern von 1982–1992 in der Kunsthalle', *Das Kunst-Bulletin*, nos. 7–8, July–August 1992, pp. 53–4

John Whitley, 'The Art of Riley', *Sunday Telegraph* magazine, 22 August 1992

Andrew Graham-Dixon, 'Earning her stripes', *Independent*, 8 September 1992

Tim Hilton, 'Strokes of originality', *Guardian*, 17 September 1992

Louisa Buck, 'Orderly passion along colour lines', *The Sunday Times*, 20 September 1992

Richard Cork, 'Colour lights up the life of Riley', *The Times*, 29 September 1992

William Packer, 'Op Art thirty years on', *Financial Times*, 29 September 1992

Brian Sewell, 'A new slant on diagonal landscapes', *Evening Standard*, 8 October 1992

Larry Berryman, 'Bridget Riley (According to Sensation)', *Arts Review*, vol. 44, October 1992, pp. 480–1

Frances Spalding, 'London, Hayward Gallery: Bridget Riley – Paintings 1982–1992', *Burlington Magazine*, vol. 134, no. 1076, November 1992, p. 939

Tim Hilton, 'New pattern to the ever-changing life of Riley', *Independent on Sunday*, 27 December 1992

Judith Bumpus, 'Bridget Riley', *Contemporary Art*, vol. 1, no. 2, Winter 1992–3, pp. 33–6

Bryan Robertson, 'Bridget Riley: Work in Progress', *Modern Painters*, vol. 5, no. 3, Autumn 1992, pp. 32–3

Richard Cork, 'High hopes between the hard edges', *The Times*, 12 March 1993

Tim Hilton, 'That was the decade that wasn't', *Independent on Sunday*, 14 March 1993

Charles Harrison, 'Gossip monumentalised', *The Times Literary Supplement*, 30 April 1993

Ginny Dougary, 'Between the lines', *The Times*, 5 March 1994

Michael Bracewell, 'Psychedelic symmetries', *Observer*, 11 September 1994

Margaret Garlake, 'Bridget Riley (Tate Gallery, August 20 to October 9)', *Art Monthly*, vol. 28, no. 181, November 1994, pp. 28–9

Richard Cork, 'Regiments of colour in close combat', *The Times*, 6 February 1996

Clare Henry, 'Dizzy spells and good vibrations', *Glasgow Herald*, 17 June 1996

Michael Bracewell, 'A plea for painting', *Guardian Weekend Magazine*, 15 March 1997

Gwen McGarthy, 'Reclaiming the final word on her work', *Irish Times*, 7 May 1997

Hans-Peter von Däniken, 'Das Geheimnis des weissen Flimmerns', *Tages-Anzeiger*, Zürich, 28 May 1998

Laura Cumming, 'Riley, ace of stripes', *Observer*, 15 November 1998

Andrew Hickling, 'The life of Riley', *Guardian*, 17 November 1998

Tom Lubbock, 'Here's one in your eye', *Independent*, 17 November 1998

Lynn MacRitchie, 'Intimate display of dazzling talent', *Financial Times*, 28 November 1998

Marin Gayford, 'Puzzled by the life of Riley', *Daily Telegraph*, 23 December 1998

Stuart Wavell, 'An old master on the real artists (E.H. Gombrich at 90)', *The Sunday Times*, 4 April 1999

Richard Cork, 'Her brilliant career', *The Times* magazine, 12 June 1999

Adrian Searle, 'Eyes wide open', *Guardian*, 22 June 1999

Richard Dorment, 'It all depends on how you look at it', *Daily Telegraph*, 23 June 1999

Richard Cork, 'Dazzled by the life of Riley', *The Times*, 23 June 1999

Waldemar Januszczak, 'Is there more than meets the eye?', *The Sunday Times*, 27 June 1999

Brian Sewell, 'A persistent case of stripes before the eyes', *Evening Standard*, 1 July 1999

Andrew Lambirth, 'Optical dazzle', *Spectator*, 10 July 1999

Simon Morley, 'London: Bridget Riley', *Burlington Magazine*, vol. 141, no. 1158, September 1999, pp. 561–3

Hans-Peter von Däniken, 'Ein Erdbeben im Wahrnehmungskanal', *Tages-Anzeiger*, Zürich, 6 September 1999

John Spurling, 'In My Own Way: The paintings and writings of Bridget Riley', *Modern Painters*, vol. 12, no. 3, Autumn 1999, pp. 34–8

Georg Imdahl, 'Wille zur Welle', *Frankfurter Allgemeine Zeitung*, 8 December 1999

Michael Kimmelman, 'Modern Op', *New York Times* magazine, 27 August 2000

William Feaver, 'Dangerous Curves', *Artnews*, vol. 99, no. 8, September 2000, pp. 116–18

Michael Kimmelman, 'Not so square after all', *Guardian*, 28 September 2000

Roberta Smith, 'Saluting a Pure Form of Abstraction, Long May It Wave', *New York Times*, 29 September 2000

Alex Coles, 'Bridget Riley at Waddington', *Art in America*, vol. 88, no. 10, October 2000, p. 179

Lynn MacRitchie, 'Bridget Riley', *Elle Decor*, October 2000

Peter Schjeldahl, 'British Flash', *New Yorker*, 6 November 2000

Christopher Knight, 'Seeing the Top of the Op Artists', *Los Angeles Times*, 25 November 2000

Patrick Bahners, 'Sie ist die wahre Erbin Elstirs', *Frankfurter Allgemeine Zeitung*, 21 April 2001

Carol Kino, 'Bridget Riley: The Pleasure of Pure Seeing', *Art in America*, vol. 89, no. 4, April 2001, pp. 112–19

Christiane Fricke, 'Das Auge tanzt quer und gerade', *Süddeutsche Zeitung*, Krefeld, 8 April 2002

Michael Kohler, 'Die Intuition der Farbe', *Frankfurter Rundschau*, 11 April 2002

Janneke Wesseling, 'Gestuwd door de wind', *NRC Handelsblad*, 26 April 2002

Paintings

1
Movement in Squares 1961
Tempera on board
123.2 × 121.3 cm / 48½ × 47¾ in
Arts Council Collection,
Hayward Gallery, London

2
Opening 1961
Tempera and pencil on composition
board
102.6 × 102.7 cm / 40 × 40 in
National Gallery of Victoria, Melbourne
Felton Bequest 1967

3
Black to White Discs 1962
Emulsion on canvas
178 × 178 cm / 70 × 70 in
Private Collection

4
Tremor 1962
Emulsion on board
122 × 122 cm / 48 × 48 in
Private Collection

5
Blaze 1 1962
Emulsion on board
109 × 109 cm / 43 × 43 in
Private Collection

6
Dilated Centres 1963
Acrylic on linen
170.2 × 170.2 cm / 67 × 67 in
Private Collection

7
Burn 1964
Emulsion on board
56 × 56 cm / 22 × 22 in
Private Collection

8
White Discs 2 1964
Emulsion on board
104 × 99 cm / 41 × 39 in
Private Collection

9
Crest 1964
Emulsion on board
166.5 × 166.5 cm / 65½ × 65½ in
British Council Collection

10
Descending 1965
Emulsion on board
91.5 × 91.5 cm / 36 × 36 in
Private Collection

11
Hesitate 1964
Oil on canvas
106.7 × 112.4 cm / 42 × 44¼ in
Tate
Presented by the Friends of the Tate
Gallery, 1985

12
Remember 1964
Acrylic on board
106.7 × 113 cm / 42 × 44½ in
Kerry Stokes Collection

13
Static 3 1966
Emulsion on canvas
163.2 × 163.2 cm / 64¼ × 64¼ in
Museum of Contemporary Art, Sydney
J.W. Power Bequest, purchased 1967

14
Cataract 3 1967
PVA on canvas
221 × 222.9 cm / 87 × 87¾ in
British Council Collection

15
Late Morning 1967–8
PVA emulsion on canvas
226.1 × 359.4 cm / 88⅞ × 141⅝ in
Tate. Purchased 1968

16
Rise 1 1968
Acrylic on canvas
188.2 × 376 cm / 74 × 148¼ in
Sheffield Galleries and Museums Trust

17
Persephone 2 1970
Acrylic on canvas
212 × 168 cm / 85⅝ × 66¼ in
N.M. Rothschild & Sons Ltd.

18
Veld 1971
Acrylic on linen
191.5 × 395 cm / 75⅜ × 155½ in
National Gallery of Australia, Canberra
Purchased 1977

19
Cantus Firmus 1972–3
Acrylic on canvas
241.3 × 215.9 cm / 95 × 85
Tate. Purchased 1974

20
Pæan 1973
Acrylic on canvas
289.5 × 287.3 cm / 114¼ × 113⅛ in
National Museum of Modern Art, Tokyo
(not exhibited)

21
Rattle 1973
Acrylic on linen
153.3 × 381.3 cm / 60⅜ × 150⅛ in
Private Collection

22
Aurum 1976
Synthetic polymer paint on linen
105.5 × 272 cm / 41½ × 107 in
Art Gallery of New South Wales
Purchased 1976

23
Song of Orpheus 3 1978
Acrylic on linen
195.6 × 259.7 cm / 77 × 102¼ in
Private Collection

24
Andante 1 1980
Acrylic on linen
182.8 × 169 cm / 72 × 66½ in
Private Collection

25
Streak 2 1979
Acrylic on canvas
113.7 × 251.5 cm / 45½ × 99 in
Private Collection

26
Silvered 1981
Oil on linen
240.7 × 203.2 cm / 94¾ × 80 in
Private Collection

27
Big Blue 1981–2
Oil over synthetic polymer paint on linen
234.5 × 201 cm / 93¾ × 79¼ in
Queensland Art Gallery
Purchased 1984

28
Bali 1983
Oil on linen
237 × 195.1 cm / 93¼ × 76¾ in
Private Collection

29
Tabriz 1984
Oil on canvas
217.2 × 181 cm / 85½ × 71¼ in
Private Collection

30
Justinian 1988
Oil on linen
165 × 226 cm / 65 × 89 in
Private Collection

31
Reflection 2 1994
Oil on linen
165 × 228.4 cm / 65 × 90 in
Private Collection

32
From Here 1994
Oil on linen
156.2 × 227.3 cm / 62 × 89⅝ in
Private Collection

33
Composition with Circles 2 2000
Acrylic on plaster wall
400 × 1370 cm / 157½ × 539⅜ in
Dia Art Foundation, New York
(illustrated, not exhibited)

34
Composition with Circles 4 2004
Acrylic on plaster wall
392.2 × 1671.2 cm / 154½ × 658 in
Kerry Stokes Collection, Perth
(exhibited, not illustrated)

35
Lagoon 1 1997
Oil on linen
147 × 193 cm / 58 × 76 in
Private Collection

36
Rêve 1999
Oil on linen
228.3 × 238.1 cm / 89⅞ × 93¾ in
Private Collection

37
Parade 2 2002
Oil on linen, two panels
226.7 × 527.4 cm overall /
89¼ × 207⅝ in overall
Private Collection

38
Evoë 3 2003
Oil on linen, two panels
193.4 × 579.8 cm overall /
76⅛ × 228⅛ in overall
Tate
Presented by Tate Members 2003

Works on paper

39
Cartoon for *Blaze* 1962
Pencil and scotch tape on paper
87 × 87 cm / 34¼ × 34¼ in
Collection of the artist

40
Untitled Study 1963
Gouache and pencil on graph paper
88.9 × 114.3 cm / 34⅝ × 44½ in
Collection of the artist

41
Study for *Twist* 1963
Gouache and pencil on graph paper
23 × 34 cm / 9 × 13½ in
Collection of the artist

42
Study for *Twist* 1963
Pencil on graph paper
25.2 × 45.3 cm / 9¾ × 17⅝ in
Collection of the artist

43
Untitled (Study for *Climax*) 1963
Gouache on graph paper
29.5 × 33.5 cm / 11⅝ × 13⅛ in
Collection of the artist

44
Study '64 for *White Discs* 1964
Gouache on paper
20 × 20 cm / 7¾ × 7¾ in
Collection of the artist

45
Study for *Shuttle* 1964
Gouache and pencil on graph paper
21.6 × 26 cm / 8½ × 10¼ in
Collection of the artist

46
Study (*Turn*) 1964
Gouache on graph paper
46.5 × 46.5 cm / 18 × 18 in
Collection of the artist

47
Study for *White Discs* 1964
Gouache on paper
27.3 × 28 cm / 10½ × 10⅞ in
Collection of the artist

48
Study for *Burn* 1964
Gouache on graph paper
39.7 × 36.7 cm / 15½ × 14¼ in
Collection of the artist

49
Study for *Warm and Cold Curves* 1964
Gouache on paper
41 × 32.4 cm / 16 × 12½ in
Collection of the artist

50
Study: '65 (Study of Triangle Mutation) 1965
Pencil on graph paper
71.1 × 102.4 cm / 28 × 40¼ in
Collection of the artist

51
Study for *Fragments Print 3* 1965
Gouache and pencil on paper
50.8 × 36.2 cm / 19¾ × 14 in
Collection of the artist

52
Untitled Study 1965
Gouache and pencil on graph paper
55.9 × 76.2 cm / 21¾ × 29⅝ in
Collection of the artist

53
Untitled Study for *Arrest* 1965
Gouache and pencil on graph paper
34.3 × 67.3 / 13⅜ × 26⅛ in
Collection of the artist

54
Study for *Static* 1966
Biro and pencil on tracing paper
50.8 × 137.2 cm / 20 × 54 in
Collection of the artist

55
Study 1966
Pencil on paper
39.4 × 69 cm / 15⅜ × 26⅞ in
Collection of the artist

56
Untitled (Right Angle Curve) 1966
Gouache on graph paper
58.8 × 55.9 cm / 22⅞ × 21¾ in
Collection of the artist

57
Study for *Deny* Series: Warm Greys, Dark Cool Grey Ground 1966
Gouache on paper
48 × 51.6 cm / 18⅞ × 20¼ in
Collection of the artist

58
Untitled (Study for *19 Greys*) 1966
Gouache and pencil on paper
34.3 × 25.4 cm / 13½ × 10 in
Collection of the artist

59
Untitled (Study for *19 Greys*) 1966
Gouache and pencil on paper
34.3 × 26.7 cm / 13½ × 10½ in
Collection of the artist

60
Scale Study for *19 Greys* 1966
Gouache on paper
44 × 61 cm / 17⅛ × 23¾ in
Collection of the artist

61
Final Study for *Chant* Series. Darker Blue 1967
Gouache on paper
101.6 × 69 cm / 27¼ × 40 in
Collection of the artist

62
Scale Study for *Cataract* Series (Turquoise and Red Greys) 1967
Gouache on graph paper
93.8 × 29.4 cm / 36½ × 11½ in
Collection of the artist

63
Turquoise and Red Greys with Black in Separate Curvilinear Segments 1967
Gouache on graph paper
47 × 53.5 cm / 18¼ × 20⅞ in
Collection of the artist

64
Three Pairs Organised in Takeover Movement of 3: (Study for *Late Morning 1*) 1967
Gouache on graph paper
17.5 × 71.5 cm / 6⅞ × 28⅛ in
Collection of the artist

65
Study for *Late Morning 2*: Long Sequence 1967
Gouache on graph paper
16.5 × 207.6 cm / 6½ × 81¾ in
Private Collection

66
Study for *Byzantium* 1968
Gouache and pencil on graph paper
26.7 × 50.5 cm / 10⅜ × 19⅝ in
Collection of the artist

67
Untitled 1969
Gouache and pencil on graph paper
36.1 × 49.5 cm / 14 × 19¼
Collection of the artist

68
Study for *Apprehend* 1970
Gouache on paper
71.8 × 57.8 cm / 28¼ × 22¾ in
Collection of the artist

69
Scale Study for *Zing 1* 1971
Gouache on paper
101.6 × 38.1 cm / 40 × 15 in
Collection of the artist

70
Red and Green Twisted Curves 1972
Gouache on paper
21 × 168.3 cm / 8¼ × 65½ in
Collection of the artist

71
Study '72: Three Colours in Different Orders with Black 1972
Gouache on paper
45.7 × 73.2 cm / 18 × 28¾ in
Collection of the artist

72
Sequence Study: Bright Green, Blue and Red 1973
Gouache on paper
30.5 × 167.6 cm / 12 × 66 in
Collection of the artist

73
Study '72–3: Sequence for *Cantus Firmus* 1973
Gouache on paper
53.3 × 70.5 cm / 21 × 27¾ in
Collection of the artist

74
Study for *Pæan*, Situation 2 A–B, C–D: Bright Green, Red and Blue surrounding one another 1973
Gouache on graph paper
24.1 × 96.5 cm / 9½ × 38 in
Collection of the artist

75
Untitled (Study for *Rattle*) 1973
Gouache on paper
59 × 101.5 cm / 23¼ × 40 in
Collection of the artist

76
Study for *Aurum* 1976
Gouache on paper
116.5 × 286.8 cm / 45⅜ × 111⅞ in
Collection of the artist

77
Study for *Clepsydra* 1976
Gouache on paper
203.2 × 257.2 cm / 80 × 101¼ in
Collection of the artist
(not exhibited)

78
Twisted Curves 1977
Pencil on paper
61.6 × 91.4 cm / 24¼ × 36 in
Collection of the artist

79
2 Colour Twist: Blue/Red and Violet/Yellow, Series 41 – Green added 1979
Gouache on paper
97 × 50.5 cm / 38⅛ × 19⅞ in
Collection of the artist

80
Series 41: Red added – Green and Violet, Blue and Yellow 1979
Gouache on paper
97 × 50.5 cm / 38⅛ × 19⅞ in
Collection of the artist

81
1st Cartoon for one of *Ka* Series 1980
Gouache on paper
75.6 × 68 cm / 29¾ × 26¾ in
Collection of the artist

82
Black and White Rhythm 1980
Gouache on graph paper
27.3 × 58.4 cm / 10¾ × 23 in
Collection of the artist

83
Green, Red, Blue and Yellow. Revision of N5 1980
Gouache on graph paper
28 × 55 cm / 10⅞ × 21½ in
Collection of the artist

84
Rough Stripe Study with Blue, Turquoise, Red and Yellow (Towards *Après Midi*) 1981
Gouache on graph paper with collage
104 × 71 cm / 41 × 28 in
Collection of the artist

85
Rough Study 2 towards *Silvered* 1981
Gouache on graph paper
95.1 × 71 cm / 37 × 27⅝ in
Collection of the artist

86
Rough Stripe Study with Blue, Turquoise, Yellow and Green 1983
Gouache on graph paper with collage
96.5 × 78 cm / 38 × 30¾ in
Collection of the artist

87
Study B: 15/10/85 1985
Gouache on paper
62.5 × 55.2 cm / 24⅜ × 21½ in
Collection of the artist

88
Further Revision of June 29th A (Rough Study for *Ease*) 1986
Gouache and pencil on paper
72.5 × 68.5 cm / 28½ × 27 in
Collection of the artist

89
Rough Study for Revision of *February 14* (B) 1988
Gouache and pencil on paper with collage
71 × 91.5 cm / 28 × 36 in
Collection of the artist

90
Rough Study. July 2nd 1991
Gouache and pencil on paper
68.5 × 91.3 cm / 26⅝ × 35½ in
Collection of the artist

91
Rough Study. July 4th 1991
Gouache and pencil on paper
66.6 × 91.5 cm / 26 × 35⅝ in
Collection of the artist

92
Rough Study for June 25th '92 Bassacs
1992
Gouache and pencil on paper
68.2 × 87.4 cm / 26½ × 34 in
Collection of the artist

93
Rough study for June 29th '92 Bassacs.
Study for Conversation 1992
Gouache and pencil on paper
69.6 × 91.3 cm / 27 × 35½ in
Collection of the artist

94
Red and Yellow Ground Study 1998
Gouache on paper
72.4 × 91.5 cm / 28½ × 35⅝ in
Collection of the artist

95
Ground Study for 28th August '98
1998
Gouache on paper
104.5 × 72.2 cm / 41⅛ × 28½ in
Collection of the artist

96
Study 3 for Curvilinear Grid 1998
Pencil on graph paper
103.8 × 71.8 cm / 40⅞ × 28¼ in
Collection of the artist

97
Rough Study for September 17th
Bassacs '99 1999
Gouache on paper
48.8 × 56.8 cm / 19 × 22⅛ in
Collection of the artist

98
Oil Colour Test for Rêve 2 1999
Oil on linen
81 × 82.5 cm / 31½ × 32⅛ in
Collection of the artist

99
Tracing for a Revision of September 23
Bassacs '99 1999
Gouache and pencil on paper with
tracing paper
42.5 × 86 cm / 16½ × 33½ in
Collection of the artist

100
Ground Study for 18th April '00
Bassacs 2000
Gouache on paper
86.5 × 61.3 cm / 33⅝ × 23⅞ in
Collection of the artist

101
Rough Study for Revision of 31st
December '00 2000
Gouache on paper
47.5 × 91.4 cm / 18½ × 35½ in
Collection of the artist

102
July 4 '00 Bassacs Study 11 for
Composition with Circles 2 2000
Pencil on paper
38 × 96.5 cm / 14¾ × 37½ in
Collection of the artist

103
Sheet 1 Analysis of Study 11 for
Composition with Circles 2 2000
Pencil on paper
36.5 × 96.5 cm / 14⅛ × 37½ in
Collection of the artist

104
Sheet 2 Analysis of Study 11 for
Composition with Circles 2 2000
Pencil on paper
36.5 × 96.5 cm / 14⅛ × 37½ in
Collection of the artist

105
Rough Study for Blues and Greens
2001
Gouache on paper collage
47.5 × 91.5 cm / 18¾ × 36 in
Collection of the artist

106
Final Cartoon for Apricot and Pink
2001
Gouache on paper mounted on linen
129.5 × 228.5 cm / 50½ × 89 in
Collection of the artist

107
Rough Study for Yellows and Blues
2002
Gouache on paper collage
47.5 × 91.5 cm / 18¾ × 36 in
Collection of the artist

108
Tracing of Revision to Parade 2 2002
Pencil on tracing paper
37.5 × 83 cm / 14½ × 32⅜ in
Collection of the artist